new**ART**theatre

THE PERFORMANCE IDEAS SERIES

PERFORMANCE IDEAS explores performance that crosses boundaries of all live art forms and media. The series highlights the long-standing editorial commitment of PAJ Publications to bring together the histories of performance in theatre and in visual art for a more expansive vision of artistic practice.

new**ART**theatre

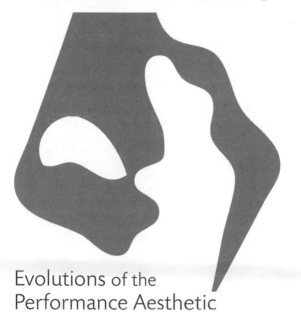

Evolutions of the
Performance Aesthetic

PAUL DAVID YOUNG

New York, New York

newARTtheatre is published by PAJ Publications, P.O. Box 532, Village Station, New York, NY 10014.

PAJ Publications is distributed to the trade by Consortium Book Sales and Distribution: www.cbsd.com

Publisher of PAJ Publications: Bonnie Marranca

Publication of *newARTtheatre* is made possible by the New York State Council on the Arts with the support of Governor Andrew Cuomo and the New York State Legislature.

Library of Congress Cataloging-in-Publication Data
Young, Paul David.
 newARTtheatre / by Paul David Young.
 pages cm
 ISBN 978-1-55554-158-3
 1. Theater—Aesthetics. 2. Theater—Philosophy. I. Title. II. Title: New art theater.
 PN2039.Y68 2013
 792.01—dc23

 2013037517

First Edition

Contents

Metamorphosis

How Visual Artists Turn Theatre into Art

NewARTtheatre: Evolutions of the Performance Aesthetic is a series of dialogues with contemporary visual artists who are appropriating theatre. While historically in the closed universe of art performance and visual art, theatre has most often been taboo, today many artists have come to terms with their use of theatre. Rather than shrinking from the opprobrium of being theatre artists, they turn consciously to theatre in order to expand their artistic practice in terms of both means and ends. In theatre, they have discovered powerful methods to make art and ways of addressing social and political issues.

As the compound word of the title suggests, this book is about the current use of theatre by visual artists. The freedom of visual artists to turn to theatre is new. Post-war art performance and visual art in the U.S. developed by and large in ideological opposition to theatre. In the 1960s, theatre was rejected in two very different ways. On the one hand, in the art world, the modernist critic Michael Fried famously denounced theatre as the "perversion of art" in his 1967 essay "Art and Objecthood." Fried saw the enemy in minimalism, an approach to art that activated the viewer and required an audience. On the other hand, as the social revolutions of the 1960s were unleashed, those in the vanguard of experimental theatre felt that they should abandon or destroy traditional theatre since it was a product of decadent bourgeois culture. When viewed from this

1

critical political perspective, theatre's rehearsal, prepared text, professional actors, division of spectator from performer, narrative impetus, and commodified consumption perpetuated the patriarchal rigidity of capitalist society. Thus, the word "theatre" became a way of describing what art was not.

Not only art performance as a genre, but its critical reception as well has been radically separated from theatre in the post-war era. As Bonnie Marranca argued in her 1999 essay in *PAJ*, "Bodies of Action, Bodies of Thought," apropos of the 1998 exhibition at the Museum of Contemporary Art in Los Angeles, *Out of Actions: Between Performance and the Object, 1949–1979*, the art world's narrative of post-war performance history fails to integrate theatre history, despite the obvious relationship between theatre and performance in their use of forms and the issue of audience reception.

It is against this backdrop that the appropriation of theatre emerges as a significant trend today in the work of visual artists and in the institutional reception of art. Some visual artists, such as Eleanor Antin, Joan Jonas, Scott Burton, and Paul McCarthy, to be sure, were using theatre all along, despite the denunciation of the form by the reigning ideologies. Other visual artists, who have taken up theatre more recently, find themselves less encumbered by the prejudices of modernist visual art criticism and are discovering in theatre many useful methods to pursue in their work. Theatre functions as a toolbox, offering practices that lead to the creation of visual art. For some artists, the experience of the processes of theatre is in effect the work of art: collaborative interpretation of the text, for instance, is an exemplary communal enterprise. For

others, the fascination is with theatrical ephemera, the parts of theatre that exist outside the performance, such as rehearsal and auditions, which more readily retain a feeling of liveness and spontaneity. For still others, the dramaturgical concept of character draws them to theatre as a vehicle to explore identity and ideology. In some cases, theatre texts, from ancient Greek classics to Samuel Beckett, provide references and conceptual vessels that may ground or augment the reception of visual art. For many artists, the theories of theatre (such as the writings of Bertolt Brecht and Augusto Boal) are a framework for developing forms of art performance.

Many factors and trends tend to encourage the use of theatre in art today. In part, theatre may be available for appropriation by visual artists now because as a cultural phenomenon theatre has declined considerably in its importance to the society at large and, viewed by some artists as a dead art form, is therefore fair game. Another factor may be generational change. The anti-theatre values and taboos of the 1960s may appear to the younger generation as something to be productively defied and reexamined. To become the vanguard, today's artists must stake out a new position, in opposition to what has come before. Moreover, the use of media, and particularly the ubiquity of video in contemporary visual art, may have helped to overcome the prohibition on theatre. If there are bodies appearing before the camera, reciting texts in some fashion and creating the impression of narrative, however disjunctive in form, it is only natural that visual artists would discover the antecedent tradition of theatre. Similarly, in photography, the staged photographs of Francesca Woodman, Martha Wilson, Cindy

Sherman, and Laurie Simmons, for example, are linked to the-
atre, as they invoke acting, theatrical props, sets, and narrative.

In addition, the widely recognized trend toward the dema-
terialization of the art object finds in theatre a ready-made
form: theatrical performance has always been ephemeral and
experiential. Specifically, Fluxus, a movement grounded his-
torically in forms of participatory theatre, maintains consider-
able currency among contemporary visual artists and curators.
Moreover, contemporary art is based largely in conceptualism,
which often inclines in practice toward performance and thus
also leads visual artists back to the prototype of theatre.

The communal practices and immateriality of theatre make
it an attractive medium as artists explore political themes.
When seen as an inherently social medium (collaborative work
not only among the designers and performers but also with and
through the audience), theatre offers an ancient and well-devel-
oped set of practices to deploy. Street theatre as a model for
art interventions lends itself readily to political engagement,
as the work of Suzanne Lacy has demonstrated for decades.
Recently, Sharon Hayes has attracted attention for her stag-
ing or restaging of public protests and showing the resulting
video documentation in a gallery setting. In her exhibitions,
she has also displayed archival audio and video documentation
from demonstrations of the 1960s that she has reformatted or
reconfigured. For example, in her project *In The Near Future*
(2005–09), a performance staged on the streets in Brussels,
London, New York, Paris, Vienna, and Warsaw, Hayes held up
placards with historically accurate or newly invented slogans at
sites known for past public protests. Hayes's street theatre was

accorded a solo show at the Whitney Museum in 2012, and she won a "special mention" award at the 2013 Venice Biennale for, in the jury's words, "making us re-think the importance of alterity and the complexity of the interplay between the personal and public."

In this vein, the use in the art world of what looks like the participatory theatre of the 1960s and 1970s has furthered the incursion of theatre into visual art spaces, institutions, and audiences. A subfield of this has come to be referred to as "social practices," as, for example in the writings of Shannon Jackson who has explored this side of art production in her book, *Social Works*, or in the work of Lacy, as she has described it in her book *Leaving Art*. A contrary point of view, deploring the degradation of art by its funding mechanisms and the politics of community and identity, has been expressed by the critic Claire Bishop in her 2012 book *Artificial Hells*. Bishop's criticisms were, in many ways, anticipated in Marranca's earlier essay, "Bodies of Action, Bodies of Thought," in which, among other things, she questioned the widely accepted assumption that performance is linked to democratic participation in the political sphere properly speaking.

The experience of visual art is now often conceived of as a performance in which the spectator activates the artwork through the perception and interpretation of her surroundings. This is precisely what Fried had feared. The objects and space in which they are displayed are no longer seen as inert, independent, and timeless. Rather, they exist in specific contexts and their significance varies, depending upon how they appear to the viewer. They thereby acquire a narrative

and political meaning that can no longer be ignored. The dramatic performances of Andrea Frasier, impersonating an art critic or docent, are built on these themes. This historiographically sensitized understanding of visual art underlies the critical discourse surrounding the constitution of the subject and the nature of subjectivity. Similarly, relational aesthetics, that is, the overt consideration of the social context of the creation and reception of art that was initiated by the writings of Nicolas Bourriaud, converts the experience of art into a kind of improvisational theatre. Likewise, the interest in durational art performance, which occurs over hours, days, or even years, intentionally exceeding the capacity of the spectator to perceive the entirety of the work, is meant to overstep the traditional architectural and critical boundaries and to transform art into live theatre.

As theatre gains ground in the art world, the qualities once deemed essential to most art performance, those of being unrehearsed and unrepeatable, are no longer as dominant. Repetition has gained respectability and whittled away at the art world's resistance to theatre and the attempts to distinguish art and theatre, as Rebecca Schneider has discussed in her book *Performing Remains*. Reenactments of performance art, such as *Seven Easy Pieces*, Marina Abramović's 2005 New York Guggenheim Museum re-performance of various works originally created and personally performed by other artists, and her 2010 retrospective at the Museum of Modern Art, *The Artist is Present*, in which dancers and actors were trained to re-perform her earlier work, have further eroded the boundary between art and theatre. She had said in 1978: "The spontaneity which is

an important factor in our work comes about because we do not rehearse or repeat a performance."

Art world institutions have recently turned a welcoming eye toward theatre, as performance in its various denominations becomes more central to contemporary visual art practices. In New York alone, the trend is quite clear. The Performa 11 biennial hosted numerous traditional theatre pieces and works that incorporated references to, or the practices of, theatre, though most often avoiding mentioning the forbidden by name. The 2012 Whitney Biennial focused squarely on performance and featured a staged play, puppetry, dance theatre, and an extended rehearsal in the museum conducted by the theatre director Richard Maxwell. When it relocates downtown, the Whitney has announced that performance spaces will be incorporated into the architectural design, including a fully equipped black box theatre. The Guggenheim Museum has also turned into a theatre impresario on occasion of late. The atrium of the Museum of Modern Art, a product of the most recent renovation, has become a venue for dance theatre and other kinds of performance. The New Museum performance program in its new home on the Bowery has included work that for all intents and purposes is theatre. What is happening in New York can also be seen internationally. At the 2013 Venice Biennale, the Golden Lion—the top prize for an individual artist in the international exhibition—went to Tino Sehgal, whose works are performed live by hired actors who follow a script he has devised.

The panelists and interviewees in *newARTtheatre* were selected not only because of their distinction as visual artists

whose work has drawn critical attention but also because of the diversity of their positions within the visual art world as well as their approaches to theatre. Some of these artists have consistently and unapologetically turned to theatre, and they are known primarily for their work in theatre. Other panelists have deployed theatre more recently and in forms more self-conscious, fragmented, and critical. Rather than interpreting their work within a theoretical scheme, these conversations permit the artists to frame their practices and to engage with the issues surrounding theatre in their own terms. They talk about what theatre means to them and how they understand its use in their creative processes and work. They explain how and why they are now turning theatre into art.

I hope that this book will foster a dialogue among artists and critics across disciplines. It seems too often the case that the art world is unaware of the rich and varied 2,500-year history of theatre in the West, not to mention the Eastern theatrical traditions. Likewise, beyond the use of video on the stage, theatre could do well to examine how the visual art world is able to maintain a more contemporary conversation with the culture and to evolve much more nimbly. There is a great deal to be learned on both sides.

I would like to thank PAJ Publications and its publisher, Bonnie Marranca, for the opportunity to explore these issues and to initiate a productive dialogue between theatre and visual art. I am indebted to all of the artists who spoke with me for lending their time and sharing their thoughts about their practices and work. I would also like to thank the persons and institutions that so generously hosted the panels: Steven

Rand of apexart, Claire Montgomery of Location One, and Travis Chamberlain of New Museum. I am very much obliged to Ricky D'Ambrose as copyeditor for his careful work on the text. I am grateful to my partner, the artist Franklin Evans, for his support and encouragement and the pleasure of our daily dialogue about art and theatre.

Theatrical Ephemera and Alternative Performance Spaces

A Conversation with John Kelly, Liz Magic Laser, David Levine, and Alix Pearlstein

The use of theatre within the art world raises a host of questions about the identity and body of the performer, performance and the written text, the institutional and social conditions of performance, the relevance of the history of theatre and theatre criticism, and the political aspirations of art. Artists turning to theatre today are effectively contesting the prevailing aesthetic dogma of art performance that ties the artwork to the body and identity of the performer. When artists use professional actors, they are necessarily removing the physical presence of the artist and redefining his role.

The use of theatre also raises another set of questions about the notion of re-performance. In art performance a premium has often been placed on the uniqueness of one-time-only, unrehearsed performance, theatre involves repetition and, through the script, predetermination of action and speech. The definitions of both theatre and art are being put into play by this cross-boundary activity. The appropriation of theatre into the art world challenges the architecture and social conventions of theatre. In theatre, the audience sits in a fixed position in the dark for a specific amount of time while the action occurs in the separate space of the stage. The art world upturns

these expectations by using a form of theatre that is perceived through sampling, the audience free to come and go and to move around in the space. The social conditions of performance thus reveal themselves as determinative of the experience. Concurrently, as art performance begins to resemble theatre, the understanding of art changes as well. It must be asked: What critical standards should be applied to the use of theatre in the visual art context. What weight should be given to virtuosity? How does theatre in the art context relate to the history of theatre and to the history of art?

Why are artists turning to theatre now? One answer is politics. As theatre is inherently a social medium and a text-based art form, it has the capacity to engage in political discourse. Artists look back to the historical avant-garde and the development of agit-prop theatre during the Communist revolutions for inspiration. Another answer may lie in the decayed condition of theatre today, since it has been pushed to the side by other forms of culture and media. Some regard theatre as a dead art form, which makes it ripe for plunder.

The work of John Kelly, Liz Magic Laser, David Levine, and Alix Pearlstein take up these themes in their work. They explicitly engage with theatre, though in ways that are, for many in the theatre world, unconventional. Common among all of them is the decentering of the text, or even its complete elimination in performance. Levine and Pearlstein open up the world of theatre by focusing on theatrical ephemera, those parts of theatre that traditionally exist outside the performance. Laser and Pearlstein work in video, taking the live event of theatre and manipulating it in startling ways. Kelly,

by contrast, prefers live theatre performances that focus on art and artists.

JOHN KELLY's performances often deal with the lives of visual artists, and he exhibits his drawings and paintings in art galleries. He has received numerous awards, including two Obies, two Bessies, and a CalArts Alpert Award. Fellowships and residencies include the American Academy in Rome, Guggenheim Foundation, Radcliffe Institute, Civitella Ranieri, and the Sundance Theatre Lab. He has created biographical pieces that evoke the lives and work of Caravaggio, Egon Schiele, and Joni Mitchell.

LIZ MAGIC LASER develops her work out of scripts taken from the Internet, Brecht, and film, all of which she translates into performance, video, and photography. She attended the Whitney Museum Independent Study. Her 2010 solo show at Derek Eller Gallery in New York was *chase*, a restaging of Brecht's *Man Is Man* in several ATM outlets of Chase Bank. Laser's work was included in *Greater New York 2010* at MoMA PS1 where her performance, *Flight*, debuted. *Flight* excerpted famous chase scenes from the history of cinema, which were performed live. She has created projects for Art Production Fund, Performa 11, and the New York Armory Show.

DAVID LEVINE scrambles theatre conventions, exploring duration, spectatorship, theatre architecture, and the actor as worker. His performances have been seen at MoMA, documenta 12, GBE@Passerby, PS 122, the Watermill Center, MASS MoCA, and HAU2 Berlin. He is director of the Studio Programme at the European College of Liberal Arts. In his *Bauerntheater*, he adapted Heiner Müller's *Der Umsiedler*

as a wordless performance by a method actor planting pota-
toes on a farm outside Berlin. For *Habit*, he commissioned a
melodrama, which was performed as if on a loop for over seven
hours each day; the spectators were free to sample the play by
entering and exiting the performance area at will.

ALIX PEARLSTEIN creates video using professional actors and
virtually wordless scripts. She has on occasion turned to popular
theatre for inspiration, as in her 2009 companion pieces, *Talent*
and *Finale*, which drew upon the Broadway musical *A Chorus
Line*. Selected solo exhibitions include On Stellar Rays, New
York; Contemporary Art Museum, St. Louis; The Kitchen, New
York; MIT List Visual Arts Center, Cambridge; Salon 94, New
York; Lugar Commun, Lisbon; The Museum of Contemporary
Art, Chicago; and Postmasters Gallery, New York.

*The discussion took place in October 2010 at the apexart gal-
lery in New York and continued by e-mail after that evening;
these later questions and answers are appended at the end of
the conversation.*

YOUNG: I'd like to thank apexart for agreeing to host tonight's
panel and *PAJ: A Journal of Performance and Art,* under whose
auspices the panel is occurring. The reference to traditional
theatre by visual artists was largely excluded from the idea of
performance art since the 1960s. On the one hand, there was
Michael Fried's famous condemnation of theatre as the nega-
tion or perversion of art, in his discussion of the aesthetics of
minimalism in the essay "Art and Objecthood," and on the

other hand performance artists such as those at the Judson Memorial Church were developing an aesthetic that was often defined in opposition to traditional theatre as a rehearsed performance determined by a written text, the so-called literary theatre, as it's often disparaged.

Theatre is often regarded as a dead art form, one that can be excruciating. I was reading Steve Dixon's *Digital Performance*, which summarized the reaction of many people to traditional theatre. He wrote: "We have all experienced nights of crushing, excruciating boredom at the theatre where despite the live presence of a dozen gesticulating bodies on stage, we discern no interesting presence at all and pray for the thing to end." Contrary to that, I think that the work that is being produced by the artists I've assembled here tonight is a fascinating use of theatre.

Let me begin with Alix Pearlstein. I'm sure many of you know Alix's work. She's a video artist. She had a recent rave-reviewed show at The Kitchen and an equally ecstatically received show at the Lower East Side gallery On Stellar Rays. Her work uses a model of performance that looks like theatre and seems to have a sort of script involved. Alix uses trained actors. I found her work to be a very beautiful and smart adaptation of the idea of theatre. In the most recent work there is a layered reference to the idea of theatre, in that she has adapted the film *A Chorus Line*, which is in turn an adaptation of the stage musical, which is in turn a reference to theatrical practices that one may see every day in the theatre. "Theatrical ephemera," is the way I would describe them. I'm not going to impute those words to you, but it's the way that it occurs to me. And I don't mean to diminish your work by describing

it that way. I think it is astonishing the way you've taken these quiet moments that are not normally considered integral to the theatre experience and created another kind of art out of them. Alix, could you begin by talking about why you chose to engage with theatre over the past several years?

PEARLSTEIN: For me it comes more from working with actors in an art context than from thinking about theatre per se. I started making sculpture and installation, and then I, like many artists, started working with video using myself as a performer. I have some background in dance so that I came to performance from the point of view of choreography. And after a while I started incorporating some friends who also perform in my work, and along the way came some friends who happen to be professional actors. I recognized something so different in the way that they approached performance in the context of what I was doing. It marked a big shift in how I worked. I started working exclusively with professional actors. That's what has drawn me to references to theatre. The difference between what performance is and what acting is—that's more where my engagement is in questions about theatre.

YOUNG: Could I ask you what you mean by that distinction?

PEARLSTEIN: When I say acting, I mean that there is a motivation and a backstory or a psychology beyond the actor that you see. Performance—you were referring earlier to Judson Dance Theater—by that I would mean that there is a sense that the performer is not pretending, that the performer or the artist is themselves doing a task. I'm interested really in both but

particularly a strange place between them and what happens when you have a professional actor navigating the bell curve between those two poles.

YOUNG: Let me introduce the other members of the panel. David Levine, whose work has also dealt with what I would term "theatrical ephemera," has a piece called *Hopeful* that has to do with the tragic landscape created by the actor's headshot and the longing that is expressed through that. In your *Bauern-theater*, or "Farmer's Play," based on the Heiner Müller play, *Die Umsiedlerin,* the text of the play has been eliminated from the performance. Could you tell us why you're engaged in theatre?

LEVINE: I was a professional theatre director for about five or six years in New York, and over the course of that I real-ized, especially with American realism being what it is, what I was much more interested in was in the ways that people try to turn themselves into somebody else. I got more and more interested in theatre and the ephemera of theatre as tracking that. So I became less interested in theatre as something to do than theatre as a way of tracking or talking about these ideas of self-transformation. But you can't talk about those questions in an auditorium. It would be like trying to ride a wheelbar-row when you're sitting in it. If you want to focus on this, you have to look at it in a different context. That's pretty much how that all shifted for me. I still really loved rehearsing but I hated going to theatre. I liked making it but I hated going. I had to work that one out. The performance-based work let me do both. It let me do traditional theatre rehearsal without hav-ing to set foot in an actual theatre, but I got to do all the rest

of it. For *Bauerntheater*, we rehearsed this play with the actor and then I shipped him out to a little land art center where the play is based, and I asked him to be in character for ten hours a day, five days a week, for a month, which basically entailed just planting potatoes by hand, doing manual labor as somebody else. He could stop working but he couldn't stop acting.

YOUNG: That has a tie to one of your other pieces, *Actors at Work*.

LEVINE: This is another piece of theatrical ephemera. There's a union called Actors' Equity that actors all belong to, and you have to belong to it. It supposedly protects you, but most actors don't make enough money. They have to get day jobs. I filed Equity contracts for actors to just go to their day jobs, so legally their work space became theatre and legally their work became a performance. Then I sent someone over to shoot production stills while the contract was in force. So, legally, they were in plays with titles like *Word Processor* or *Free Lance Editor 2*.

YOUNG: I recall that for *Bauerntheater* the rehearsals took place in New York and you filled a room with dirt

LEVINE: Yes, because it was a test of method acting, too, which I'm kind of fascinated by. It's a really American thing, this idea that you can become somebody totally different. That is a kind of endurance art. All these legends about method actors come pretty close to the kind of performance work that was being done in the sixties. I got soil samples from Germany, and in the studio I built a two-ton dirt field so the actor could really

prepare the role. We taught him German. He went as far as you could go with method acting with a super minimal task. He had to experience it all. Technically he was doing totally realistic acting. It's just everything around it was gone.

YOUNG: I read that some of the local farmers criticized his farming techniques.

LEVINE: Every farmer has his own idea of how you should do it. I had a dramaturg who was a farming major. The actor did it right according to one group of farmers, but he fucked up his wrist halfway through. He had to switch to a second equally valid historical approach. The weird thing was he hadn't rehearsed that one, which shouldn't make any difference because it's just planting potatoes. In the end all the potatoes he planted after the switch barely grew and the ones that he had this really well-rehearsed technique with, the ones that he could be in character with, grew fine. Which is just strange.

YOUNG: Our next panelist is Liz Magic Laser. She comes out of a photography background. Your recent pieces have a theatrical quality to them, and the work you presented this year at Derek Eller Gallery was an enactment of a Brecht play, *Man is Man*, only it was done at various ATMs around New York, and filmed and spliced together. What caused you to take up this play? It closed after six performances and the reviews were terrible. Even Brecht couldn't pull this off.

LASER: It opened at two places at once, Düsseldorf and Darmstadt. It was a total flop in Düsseldorf but it was a huge success in Darmstadt.

YOUNG: Peter Lorre was roundly criticized for his performance, and that led to Brecht's famous defense of him.

LASER: That was the later performance. It was originally written in 1926, and eventually Brecht was able to produce and direct it himself in 1931, which was when Brecht came out in defense of Lorre's acting. This was supposedly the first time he proclaimed his alienation technique, what the intention of that was. But just to explain my project a little, I cast this play and worked with each actor separately. The entire narrative was stitched back together eventually. A complete version of the narrative plays out in two-and-a-half hours.

YOUNG: Why did you do this?

LASER: I did a series of interventions. For two years, I kept coming back to that space, the bank vestibule. Each spring I would come back and do a smaller kind of intervention. The first one I tried to act in myself. I wrote a short script in which I acted out a fraught relationship with the ATM. That was shelved. The next year I came back and deposited prosciutto in my account and took a photograph of it. It disabled the machine so it was also then shelved. I kept considering this space. Such a variety of people pass through. It's a really diverse community that moves through that space, but there is a strict code of privacy that you do not interact. I also started thinking about how the surveillance cameras in that space represent the spread of repercussions, and that I knew bringing my camera into that space was felt as a threat to other people's privacy and sense of security. It felt like a space where this kind of activity would

bring out the social conditions that you gloss over because it's a kind of anaesthetized space where you wouldn't normally think of anything. There is elevator music playing, and it makes you a little bit of a zombie.

YOUNG: Our last panelist is John Kelly. He's performed in every conceivable venue, including the Belasco Theatre on Broadway. He's danced, he's sung, he's done it all. But he's also very active in the visual art world through drawings and paintings that are related to these performances. John, maybe you'd like to tell us a little about your piece based on the life of Egon Schiele.

KELLY: Yes, Egon Schiele was a Viennese Expressionist painter who died in 1918 at the age of twenty-eight. He was imprisoned as a pornographer. It was a kind of benchmark piece for me in my career. I did it initially in 1986 and again in 1995, and it really was a chance for me to merge my training as a dancer and my training as a visual artist, literally. In relation to theatre, especially early on, there was not a single spoken word in any of my work, although I sing and I've used song in my work a lot. But character and role-playing may be what I most have in common with theatre. Generally most of my pieces are centered on a character of some sort. It's hard for me to be me on stage, even if I'm singing a song. A song for me is a little play. And I use theatrical techniques and elements. The work is pretty theatrical.

YOUNG: I invited you not only because you are a marvelous performer but also because you are a refutation in a way of the argument that visual art and theatre have been separated. You

have engaged in visual art and theatre since about 1980. There's nothing new about crossing this boundary for you. Is that true?

KELLY: Yes. I quit art school and in the East Village I started performing in clubs. I made my debut at The Anvil lip-synching a Maria Callas recording in punk drag. So it was a way for me to get back on stage. I realized I wanted to perform again. I was doing a lot of self-portraits. But I was itching for my body to be in the world, to be in the work. My school was the clubs, Club 57, Danceteria, and I just formulated a vocabulary. In the eighties the other spaces beckoned, like PS 122 and The Kitchen. I wanted to be in those spaces, but I never really aimed to be in traditional theatre. I went kicking and screaming into theatre. I do acting now occasionally. But the thing I felt least comfortable doing was speaking. I'm a storyteller with my body and with visuals. That's really been what I have loved. But now I do speak. That is the last thing that I have added to my arsenal.

YOUNG: You touched on the idea of the body, which is central to what we are talking about here, whether or not this engagement with theatre affects the performance aesthetic, particularly as it relates to ideas about the politics of the body. For you, I think it is important that you are the performer and that it is your body on stage and your identification with the characters that you are portraying.

KELLY: Some of the works are solo and some have fourteen people in them. But definitely I usually play the primary part: I give myself the best role. That's the luxury of writing a work, so

I can do what I want. Only twice have I done work on some-body else's body. I've been choreographing dances on people, taking a piece that I was in initially and doing it with someone else in it. That only happened twice, and it was only because I couldn't be in two places at once.

YOUNG: I'd like to have the other panelists address this ques-tion. Liz, you're approaching theatre in a very different way from the way John is. Could you respond in relation to your own work?

LASER: This is a really stimulating question to think through for me, the question of why art is appropriating theatre right now, because it made me realize that I came into it because theatre was appropriating video art. A director asked me a few years ago to collaborate on the set for his play. It was a produc-tion at HERE Art Center, and somehow I found myself in the tech booth, a complete fish out of water. I worked with all the actors in that production, and I developed a relationship with one of them and continued working with her. I think that probably he asked me because of what was already happening in theatre with William Kentridge's work and Ivo van Hove's work and the incorporation of video art into theatre. Also, my mom's a choreographer, and so I grew up around dance. As her dancers became choreographers, I would photograph them. My background is totally in photography, and so this issue of how performance can expand its temporality through photog-raphy was present for me, and it precipitated that shift towards working in performance.

YOUNG: You don't normally appear personally in the videos you create.

LASER: I started out that way and then had these experiences of collaborating with dancers and theatre directors and that furthered the shift.

YOUNG: Now you would regard yourself as a director in the production mode?

LASER: No, I definitely consider myself an artist. I'm using theatre in quotes as a material substance.

YOUNG: David, this is kind of a complicated question for you. How would you talk about your personal presence within your work?

LEVINE: Do you want to talk about bodies or personal presence in the work?

YOUNG: Wherever you would like to start.

LEVINE: I was a theatre director who read a lot in art and went to see a lot of art. I was super galled that theatre was constantly getting dissed by the artists of the sixties, who were trying to make a distinction between theatre and performance art. The theatre was too clueless as an institution to even know that it was getting dissed. But since I come from theatre, what really bothered me was this cult of authenticity, which is to say that it's really happening because it's happening on your body. If you come from theatre you really don't find that argument

all that persuasive. So when I started working on the farming thing, everyone was like, so you're the one farming, right? I remember having conversations with really established performance artists and they were like, you're the one farming, and I'm like, no, I'm using an actor. One thing I really wanted to do was short-circuit this distinction. The actor is clearly working his ass off. It's clearly authentic. But he's also pretending. And there's some sense—if you're getting cut for a public or you're setting yourself on fire for a public—it's really happening, but it's not necessarily authentic. It's for the sake of spectacle. Using actors and not using myself is a way of getting the sentimentality out of it. You've got to reckon with the fact that it's a spectacle. It will no longer derive value from the fact that it's really happening except that a lot of the performance work I do is super durational but it's durational acting. You start thinking about acting as physical work and not just as a really easy means of representation. If most of your work is about somebody trying to convincingly become another person, then it's going to be biographical to an extent one way or the other. I mean, this was partially about me moving to Berlin and trying to pass as a German in some way.

PEARLSTEIN: The point of authenticity is an important one and integral to this whole conversation about incorporating actors into an art context. When I say that, I tend to mean that it's a conceptual framework. I think the art world has a resistance to a performer who is not the artist, and I find that resistance really interesting. I often get asked why I'm not in my work anymore. I can only do so much. There are certain things I can

do but an actor can do all these other things. I've been getting my feet wet a little bit by casting myself as the director, or as an extra who is the director, or a kind of bystander. The sense that there is a subject of authenticity to the artist, that the artist as the performer is more real, and yet the art world resists recognizing that authenticity when there is an actor, rather than an artist/performer.

YOUNG: You went through a similar transition as Liz did. You appeared in some of your earlier video work, and there is a piece, *Two Women*, where you are offscreen as a voice giving direction to an actor. After that, you disappear from the screen, is that right?

PEARLSTEIN: Yes. Lately, I've been wondering what happens if I insert myself as secondary or background personalities. It has been interesting to get responses to that. What I have found is that this issue of authenticity comes up. There is a comfort zone around the artist being present in the work.

YOUNG: Within the art world.

PEARLSTEIN: Within the art world. I'm still trying to understand that. That's something I'm thinking about lately.

LEVINE: Now you can use outsourced performance.

PEARLSTEIN: Or real people.

LEVINE: What fascinates me is that it cannot be narrative. It cannot be realistic. There's a sense that maybe you can use really

good video tech, maybe it can look really awesome, like a Stan Douglas piece, but for God's sake, it can't be narrative, you've got to frame it. There's this thing, and most other visual art has got beyond it: it's got to have a signature on it. It's got to be made somehow. It can't just pass through. There's a sense that really good conventional theatre with a narrative and an arc and emotional manipulations and all those things professionally done just wouldn't fly because it's too corporate, there's too much of a sheen on it. It would be like a minimalist object, a pop object. There's no signature, there's no gap, there's no flaw. It's too persuasive. It's not Brechtian enough.

YOUNG: You mentioned narrative, which relates to the question of your relationship to the written text and the literary theatre. I believe it's true for all of you in your current work that you, for the most part, reject the written text. There isn't a performance of the play, as it were. You mentioned, John, that you didn't really speak in performance until 1992, and haven't really spoken that much since. In Liz's piece, although the text is used, it seems to take a very secondary position to the other elements that are appearing. David, in the *Bauerntheater* piece you got rid of the written text. You have the actor performing, but there's nothing left of the text. Alix, your pieces are largely silent. Please feel free to disagree, but I think it's an element that joins all of you.

LASER: I feel pretty concerned with scripts, and often that is the starting point. I often feel I'm trying to loosen a script from the context that it's meant to be in and apply it to another context—in this case the bank—where it can operate on that

space in a way that will expose how things are being structured there. I've done some other pieces that look at the scripts for home security alarm systems. Types of language are usually pretty central for me.

YOUNG: Right, but for the *Man is Man* piece, you used the text for what purpose?

LASER: It was not about allegiance to the text, but I was trying to use each line in a twofold manner such that it could both convey its general meaning, its original meaning, but also make sense in the immediate context of the bank. For instance, one of the key narrative devices in that play (it's about a British soldier stationed in colonial India) is a pay book, basically the soldier's identity document, his debit card. There is a lot of direct reference to money, cash, and greed. Much of the language had direct implications in that context.

YOUNG: Alix, I'd like to hear you talk about this. There's very little dialogue in your videos.

PEARLSTEIN: It's funny because for me the dialogue is really important. It is just intermittent. Most of it is scripted. Even if it is just a word, sometimes there are parameters around how an actor can work with things they might say. Sometimes the dialogue is overlapping, so it is more about the texture that there is dialogue going on. But it never comes from a text. It comes from other elements.

YOUNG: Do you develop the text that you use through improvisation with the actors, or is it something that you write in

advance? As performed, it has an air of improvisation about it. The substance of the video is related to improvisation.

PEARLSTEIN: It is usually written in advance and it changes through some rehearsal. With the piece that you may be referring to, there is some dialogue that is scripted and some that is improvised around a set of parameters that are particular choices of things they might say and some direction about tone.

YOUNG: Why are you so sparing with language?

PEARLSTEIN: Yes, that's the better question. I definitely start with more in my pieces, and it gets cut down because it seems unnecessary. It's something I want to use more. It's been an ongoing interest to incorporate more language. But I'm also not a writer in that sense. Maybe I will become one.

LASER: It seems like there is an intense gestural script in your work though. I know that that veers away from the use of words.

PEARLSTEIN: Yes, that's more what I know, and so I'm interested in using words more, but in a particular way.

KELLY: In theatre a script is words. I've done storyboards. I've done stick figures. I just sang John Cage stuff. We would go with these squiggles. A score is a map for something that is going to be done once or more than once. There is a big argument in the art world about a word that I have a big problem with. It's not a graceful word—"re-performing" or "re-performer." I think it's

a really awkward word. For some people in the art world, a performance should be done only once, and never again. That's one idea. There are other ideas, equally valid. There are so many things in my head right now. In theatre, there can be such focus on the play's the thing, and everything else is secondary, such as the production values. I see it all as options. I see sound as an option, whether it is words or noise or song. The visuals are going to be there whether you like it or not. Why not have some control or say in how they are going to register? Movement, unless someone is completely still, but even that person is going to breathe and his eyes are going to blink, so movement will invariably occur. I like David's use of the word spectacle instead of performance. I use spectacle, I use performance, I use event, dance theatre, whatever: it's all the same thing. It is a thing that occurs with maybe one other body in whatever room. A combination of these things, the visual, the kinetic, the aural, the textural, winds up having some kind of effect. How much do you want to have control over that effect? There are different ways of doing it. There are traditional techniques. There's chance, there's happenstance, and if it's going to be done more than once, there maybe has to be some kind of map or sense of how to arrive at those things in a replicable way, and a way that is grounded in something other than just the menacing energy of a room in a given moment.

YOUNG: I'd like to address that energy in the room question by asking you to comment on what I would call the social conditions of performance. It's a big question. I'm talking about the way in which we perceive your art, not only the venue but also

the physical circumstances, the economics that are attendant
upon that; not only the participation or entrance of the audi-
ence, but also the artists, including the actors and technicians
that may be involved in your work. Would you like to com-
ment on that issue?

LEVINE: This goes with the script question as well. I like scripts.
In *Bauerntheater*, the character had to be generated off of the
script. We translated it. It was the first translation ever. We
adapted it within an inch of its life. Because of the way this
approach works, you have to generate the character from
the script. So in order to really test it, we couldn't change a
word. For the piece I'm doing next, I commissioned a real-
istic play that is set in a ranch house. Two guys, one woman,
love, money, drugs, gunplay, buried secret in the past, betrayal.
Utterly standard, not pastichey, but it is set in a ranch house.
I'm building a functioning ranch house, and they are going to
perform it on a loop all day long. It is rehearsed as theatre with
all the theatrical script analysis stuff. But it is not staged. Their
needs as people start to overlap with their needs as characters,
their boredom as actors. If they're hungry they eat; if they're
dirty they wash; if they want to play Nintendo they can play
Nintendo; if they want to run off to the next room they can
run off to the next room. But they cannot change the script.
The way it is set up is that spectators can walk around the out-
side of the house and look in the windows but they can't get
in. It's a real house. If Alix and I were playing a scene and we
had a big fight and I decide I want to run off to the bedroom
this time, if you want to see what I'm doing in the bedroom,

you've got to run around the outside of the house and look in the bedroom window.

That idea came from trying to find out what would happen if you subjected theatre to the viewing conditions of an art gallery, which is to say, the conditions of a video loop. You don't pay admission, it only happens during the day. There is no schedule around any of it. It is a sculptural object that is available to you all day long. For me the big question is really ninety-five percent of what makes theatre theatre and what makes art art are determined by the institutional conventions of the spectatorship. A lot of these things that I do are experiments with what happens if you transpose it in one direction or the other. Does it automatically become art if it loops and it's sculptural? Or is it still theatre because they are sticking to a script? The thing I hate about theatre is the architecture. I get sleepy as soon as I buy a ticket. It is just once a night. It's so sort of enervating. There's so much pressure on you to enjoy it, whereas the nice thing about a gallery is it completely leaves you alone. You come in and you leave. What the fuck ever. It is really relaxing, whereas theatre you might as well not go, you're so burdened by it before you even get there. For me the special context makes a lot of difference even to what the object is.

YOUNG: Alix?

PEARLSTEIN: If I'm in a theatre, I'm immediately uncomfortable, if it's a theatre for live performance. Let me make that distinction: not a movie theatre. I always feel so aware of the walls, and no matter what has been done to try to subvert the conventions of conventional theatre, if I am in that space, I

feel really restless, really fidgety. That has been a real impetus behind my work in the last few years, particularly the piece I did at The Kitchen, which I filmed in the black box theatre. Thinking about the black box as a shooting location brought the whole burden of the history of the experimental theatre space to bear, and I was thinking about theatre in the round. Through a very complicated camera choreography I tried to invert the conditions of theatre in the round. For me it is about working with cinematic approaches. I am trying to get the thing I do like about live performance, coming more from an interest in performance art and some experimental theatre, which is the contingency, the sense that it is never quite the same and that it is never perfect. Bringing the illusion of a cinematic experience to bear on that and then to a context that you can enter and leave. I think David's work pressures the context in a really severe way, and I'm getting interested in pressuring the viewer. I hate to even say this word, but I'm thinking about participation in some ways that may not be so horrendous as that might sound.

YOUNG: The dreaded participatory theatre. Liz?

LASER: Going back to your question about the social conditions of performance, as I started to say before, working with the director James Dacre was really pivotal for me in seeing a theatre director operate and seeing the collaborative nature of that endeavor. I feel like it influenced me intensely. It provided a model that is much more interactive, and it provided the stage, the platform, rather, for intense and antagonistic interaction. There was this almost social contract to agreeing to this

endeavor together, everyone involved, the actors, everyone involved in the performance. There was also this expectation that it be a mutually generative experience for everyone.

YOUNG: John, you've performed in all kinds of settings. I recall you performing on top of the bar at the Pyramid Club.

KELLY: Yes, initially it was the ballet and modern dance, which is the rectangle, and then it went to the bar of the Pyramid Club, and the floor of the Pyramid Club, going through the crowd and really infiltrating and warping space. But eventually it went back into the rectangle, so to speak, and I do conceive things that way. Maybe I share that with Robert Wilson to a degree in that I see pictures in my head or in my heart. I like production values. I like having control over the visuals, and that's something that production values tethered to a specific space can provide, although I also do like warping the space. I was just at Marfa and that beautiful Donald Judd army barracks. It was incredible. I had to start singing and the acoustics were also really good, and all the guards were like, "Whoah! What's that?" I would love to do a piece just walking through there, making noise. It would be beautiful. I like the rectangle as well, and within that I try to warp, but it is shackled to a lot of history and a lot of baggage and a lot of "You are stuck in the seat."

LEVINE: Alix was saying, it doesn't matter how you tart it up. You can do it environmentally, you can do it outside, you can have a million video monitors in the background, but somehow as soon as it is organized as theatre, as soon as you have

to show up at a certain time—it's happening once a night, you know, this repeatable spectacle— no matter where you are, you watch it the same way. You always carry the theatre in your head with you.

KELLY: I'd like to think the work trumps that. I hope that can happen, but it can be tough.

PEARLSTEIN: I always go back to this one William Forsythe piece, *Kammer/Kammer.* I don't know if any of you know that piece. It's the best use I have seen of video in theatre. Then again, it was more theatre than dance, but he's really a choreographer. I thought he really got it right. I saw something by Jay Scheib [*Bellona, Destroyer of Cities*] recently at The Kitchen, which I thought got it pretty right, too. He was doing something interesting with sound. They weren't "talking to the audience." You could barely hear it and yet it was really audible. It was like people having a conversation amongst themselves, and it created an actual intimacy that I think is often attempted but....

LASER: I don't think theatre is dead at all. I've seen some things in the last month. I saw *Orlando* last night. I saw the Anne Bogart *Macbeth,* a production called *Underneath My Bed* [by Florenzia Lozano], and all of those had an element of being in a traditional theatre setting or black box setting.

LEVINE: I totally think it's dead.

LASER: I think we want to be apocalyptic.

PEARLSTEIN: I think I just want to see it in another place. I don't know if it's dead, but I don't like it.

YOUNG: I have half a theory that one reason visual artists feel free to appropriate theatre is because of its reputed mortality. It's so archaic. It is open to reuse because it is dead or vilified.

LASER: It doesn't have the social reach it once had. I guess that's what we're saying.

LEVINE: Back when they were inventing performance and happenings, also back when Fried was writing, theatre was a real threat to all kinds of things. Now that the dog is super old and has lost its teeth, you don't have to distinguish yourself from it. Then you can start pulling elements back because it is not a threat to your own self-definition.

YOUNG: I wonder if your use of theatre in your conception of it is something that you would consider political or an intervention of some kind. You're using theatre because it is a social medium and has always been a social medium. Does that have any validity for any of you?

LEVINE: Only to the extent that if you feel you have to make aesthetic points, you feel in some sense that they are ethical points as well. For me, no. No politics.

YOUNG: Liz?

LASER: I suppose that is what we were just getting at. I'd like to think that there is some urge right now to grasp at the historical

avant-garde's use of theatre and agitational propaganda, that there is potentially a useful nostalgia, harkening back or grasping for a time when that kind of direct effect or unabashed political engagement was possible.

LEVINE: What's useful about second-order political engagement? What's useful about nostalgia?

LASER: The nostalgia is not that useful, but what it started to make me think of was how the use of photomontage has been theorized. It's not just nostalgic. When I mentioned my interest in agit-prop strategies I was mistaken in using the word "nostalgia." I think some of us are looking back to Soviet theatre's capacity to express social struggles and influence emancipatory movements; however, I am not advocating a nostalgic retreat to an outmoded model of activism. Theatre's prior ability to influence and provoke people seems relevant right now. Theatrical methods are now being taken up and expressed differently. I'm looking for the scenarios in which I can bring social conditions into high relief by applying a new script. The bank is a site that brings up a number of fears and anxieties, classed behavior, and concerns about what you do or do not have to protect. I try to use performance as an instrument that can disrupt these everyday situations that coordinate our complicity with the systems that regulate us. We used Brecht's script to treat bank clients as if they were interlopers in our space, implicating them in our intervention. So, yes, my use of theatre is intended to be decidedly political.

YOUNG: Alix, is theatre something political for you?

PEARLSTEIN: I wouldn't say political, no. There are always people in my work. I am interested in what happens when you have people in art. Often in my work there is a question of morality though I'm not imposing some morality. It is more of a concept in my use of narrative, as a way to agitate a narrative. I wouldn't say it is political, more sociological.

LEVINE: I should correct myself a little bit, I mean, to the extent that it's about work. The contracts and work fascinate me so much. It does become about having a job or the ways in which work would take over your life or become a role or vice versa. Or the ways in which people who represent or do representation for a living. That actually can be really grinding labor, so I'll take it back a little bit. It's mildly political.

YOUNG: How do you think we should evaluate the success of your use of theatre in an art context? Should we apply solely visual arts standards and precedents, or is the history of theatre and its critical reception relevant? [1]

LASER: The level of cross-disciplinarity in the arts seems ever increasing. I'd be hard-pressed to tease out what the current standards are in the visual arts or the theatre, though I do think the precedents set by the practices of the Soviet avant-garde, Brecht, the Living Theatre, the Wooster Group, and Boal's theatre of the oppressed are relevant to the critical reception of the work I am doing.

LEVINE: I try to distill things so thoroughly that the same piece signifies differently in different institutional contexts. Looked

at from an art perspective, I'm talking about performance art and its relationship to authenticity, narrative, and fiction. Looked at from a theatre perspective, I'm talking about futility, the history of acting, and how much the conventions that surround theatregoing—tickets, the illusion of a unique event, the auditorium—really determine your experience. But as far as I'm concerned, art critics don't need to know the theatre end to evaluate my work properly, and neither do theatre critics need to know the art end.

PEARLSTEIN: I think context determines the reception and criticality. Any other histories that you bring will be very interesting to consider, but they may not hold up.

YOUNG: How, if at all, do you think the use of theatre affects the aesthetics of performance as it has developed since the 1960s?

PEARLSTEIN: Dramatically, most often demonstrated as a form of rejection or aberration.

LASER: Theatre aims to represent our social life together, and its socially engaged form seems to have crossbred with practices in art and psychology. I'm not as interested in the traditional model of theatre where audience and actors are separated. I'm more familiar with theatre practices that facilitate confrontation between audience and performers, like Augusto Boal's forum theatre. I've been looking at his work recently and thinking about how it must have affected relational aesthetics models of performance. Though I don't know whether or not the art world practitioners are directly aware of the precedents set by Boal's work.

LEVINE: I think there is a big wave of referring to theatre in contemporary performance, but I don't really think it has had much of an effect. You can detect a kind of grim restraint in my work or in Alix's, but for the most part using playscripts or references to the auditorium doesn't really change anything. Liz's ATM piece, in all its willed choppiness and willed overacting, could have been something of Eleanor Antin's. "Theatre," in its conventional sense, implies a degree of polish and repeatability (think of Donald Judd's industrial finishes), that performance art continues to avoid in favor of spontaneity and expression (think of Abstract Expressionism). If anything, theatre—think Nature Theater of Oklahoma, Radiohole, or National Theater of the United States of America—has been influenced by the aesthetics of performance art.

YOUNG: How does the context in which your art will be received affect your use of theatre?

LASER: I see the art context as the stage for the work I'm producing, so this context has a broad constitutive effect on my representation of theatre as a method for social engagement.

LEVINE: When I'm working in theatres, I try to be as unprepared as possible (arty). When I'm working in art spaces, I try to be as prepared as possible (theatre-y). I'm convinced that half your experience of spectacle is determined by institutional conventions of spectatorship. The only way to generate a fresh experience is to short-circuit those conventions. That short-circuiting matters even more than the actual piece you're presenting. In my case, I hope, the short-circuiting is the piece.

PEARLSTEIN: The resistance between the contexts of contemporary art and theatre is what informs my use of theatre and acting. I'm interested in a generative mismatch, particularly between minimalism and emotionalism.

NOTE

1. The remainder of this conversation was conducted via e-mail.

Beckett, Brecht, and Minimalism

A Conversation with Gerard Byrne

The current art historical theory that posits the dematerialization of the art object has naturally led to an investigation of performance and its heritage in theatre. The immateriality of theatre and its processes arises from their being time-based and iterative. The very incompleteness of the theatrical script and performance provides an opening for artists to focus attention on the means of representation.

Visual artists are thus drawn to showing theatre as process as well as showing the processes of theatre. They break down theatre into its elements and cultivate the unending potentiality of a script to be re-enacted. While assuming the model of the literary theatre, that is, a performance according to a script, artists may turn to ready-made scripts from popular culture and in re-performing them provide a way to look objectively at contemporary society. Object-based art incorporated into theatrical performance becomes a prop, a piece of ephemera whose life depends on the run of the show. Artists give themselves permission to be playful with styles of acting. They can use the question of virtuosity to heighten the criticality of their work. Bad acting, or a mixture of good and bad acting, can add a frisson of alienation that curtails the seduction of mediated perception and encourages analytical observation.

GERARD BYRNE, an Irishman, has been drawn to the theatre of Beckett and Brecht. While reverential of the power of theatre

and the talents of trained actors, he remains ambivalent about theatre's historical origins in the normalization of the bourgeoisie. In order to provoke critical thought, he uses the processes of theatre and its incompleteness to create performances that are necessarily more jagged and unexpected.

He works in photography, audio, video, and live performance and often develops work in connection with a specific site. For example, he incorporates references to the museum setting as a way of raising questions about the received history of art. A 2010 large-scale video installation at Lismore Castle in Scotland, *A thing is a hole in a thing it is not*, involved four films about minimalism, including one showing art handlers manipulating minimalist sculpture in the museum in which the video was shown. The scripts that underlie his work are drawn from not only Beckett but also popular magazines, like *Playboy*. His *Why It's Time for Imperial Again* appropriates advertising copy from 1980, a promotional dialogue between Lee Iacocca and Frank Sinatra about the Chrysler Imperial.

He has shown his work at the biennials of Gwangju, Istanbul, Lyon, Sydney and Venice, and the Tate Triennial. Solo exhibitions have been at Whitechapel Gallery, London; ICA, Boston; Statens Museum for Kunst, Copenhagen; Kunstverein Düsseldorf; the Frankfurter Kunstverein; and Douglas Hyde Gallery in Dublin.

The interview took place in November 2011 in New York, as Byrne presented In Repertory, *as part of Performa 11. The process of the piece began with a live performance. While*

*being filmed before an audience, actors auditioned, as is
customary, with prepared monologues; Byrne coached them,
giving a few acting notes; and they repeated the audition
monologues. The audition space, as described here, held re-
creations of certain props and set pieces designed by artists
for dance and theatre productions in the twentieth century.
The film was to be edited and re-introduced into the space for
viewing at the end of the process.*

YOUNG: How has theatre affected your art?

BYRNE: I began working in a very concerted way with ideas
around theatre about five, six, seven years ago. It has not drifted
from my set of interests, but maybe it is less explicit right now
in what I am doing. The Performa piece, for example, is a piece
that I first made in 2004, I think.

YOUNG: This was in Dublin?

BYRNE: In Dublin, yes. *In Repertory* evinces an interest I had
in the idea of using a theatre production model as a means
of producing something for an art space. The full arc of that
project, which was unfortunately not completely realized in
Performa, involves the production of a piece on site, using
props, with actors and non-actors. There is a video documen-
tation element of it. All these activities are accumulated into
something that ultimately takes on a kind of linear form. There
is an editing process in essence, where a type of script, visual
script or documentary script, is formulated from this very dis-
parate, sometimes directed, sometimes not directed series of

activities happening in that given space. Then, at the end, that video document is relayed back into the space as a concluding moment. It is interesting the way that the project touches on the expectations and demands of different kinds of artistic models, like the gallery space and the theatre space. Its production mode does not fall within the standard models of gallery spaces. The final video edit is only ever shown in the space in which it is made. It is specific to that project and specific to that space. In that sense, even though it is a recording, it is not handled as a recording. It is handled almost as if it is a live performance. Although *In Repertory* uses tools from film production, it uses the space of the gallery and borrows as well from theatre formats. In the end, it is kind of a live work.

YOUNG: Would it be correct to say that you are using theatre as process? And is it also correct that theatre is present in whatever the end product of the process is?

BYRNE: Yes. One of the things that has always compelled me about theatre is its contingency, that it is non-definitive. I am really attracted to that. For example, the *In Repertory* piece is quite explicit in the sense that there's nothing new in it, right? By definition it is not about newness. It is about repetition and reiteration. It is about the process of citation, of citing other productions. The idea of using that as the explicit title and conceptual pretext for the project is that the project does not exist autonomously. It exists in relation to other things and it is at some level a calling up of Beckett, or whatever other conventional references are used—Brecht, Martha Graham, whatever the set of configurations and references are in a given production. One

important thing that is really distinctive about theatre is this palpable sense of historical reflexivity. There is also a geography involved in theatre. It is located. How it's performed in New York, in the Lower East Side, how it's performed in Dublin, how it's performed in Munich—contingency and situatedness.

YOUNG: You mean because it is live?

BYRNE: I guess I am talking about it in ways other than using the word "live" partly because I have some reservations about the fetishization of liveness. I am quite interested in the non-definitive character of it. I also love the sense of repetition and difference. They are really intrinsic qualities.

YOUNG: Would you say that you are involved in creating a different kind of performance art, in contradistinction to the performance art of, say, Marina Abramović or other practitioners of the 1960s or 1970s, in which there was a strong emphasis on the body and on not rehearsing, not having a script and all that?

BYRNE: I think so. It is probably quite generational, but I am a subscriber on that level. I went to a very orthodox art school and did a bit of everything. I have no background in film production or drama studies or anything like that. In that sense, my inheritance is Abramović more than Beckett, for example, in terms of my education. But I was less interested in performance because of its preoccupation with the body for the most part, like the art from the 1970s that you described. At art school I dabbled and did a bit of everything. It was quite

unfocused in lots of good ways, and my own particular niche, at least for graduate school, was an interest in photography and video. More particularly, photography. This is sort of mid-1990s grad school, and I was reading all that postmodern theory that we all were fed in grad school—all good medicine, all good stuff. I was interested in these ideas of the critique of representation, the instability of representation, and trying to figure out ways of working with it, given that I was working with still photographs a lot.

Of course that seems to be bound up with a fixity, the locking down of things. I tried to reconcile these commitments, and it occurred to me that acting was an interesting mode of representation. It was a set of regulations and principles that had to be stuck to, i.e. a script, right? But there were ways in which contingencies were allowed and differences and anomalies and particularities were allowed at the same time. There was instability and that was attractive to me.

YOUNG: Why? Because of postmodern theory?

BYRNE: Exactly. Theatre seemed to open up possibilities, and I realized that there was a way in which I could work with the camera in a type of reciprocal relationship with the performer. What I am describing is very elemental but I am talking about my formative period in grad school and then a little bit later. Out of that very basic set of interests, I ended up reading some Brecht, and I recognized a lot of stuff that just made sense to me. I found reading Brecht really liberating.

YOUNG: The writings on theatre?

BYRNE: Yes. That seemed to open up all kinds of possibilities, the connectivity to visual arts, to the idea of props and a certain historical perspective of drama—dialogical relationships, and unstable signification—all this stuff that Brecht is a patron of, you might say. That was really formative for me in terms of giving me permission to do things that I might not have given myself permission to do artistically otherwise.

YOUNG: So then the use of theatre for you becomes a way of illustrating these theoretical principles?

BYRNE: No. I think at this point I have moved beyond that sort of labor—working through, trying to ingest and digest theory. I have just outlined my formation. I am interested in the possibilities of representation and storytelling and narratives, but I'm also interested in how they break down. I am interested in all the contingencies that surround them. At least for the last decade I have been interested in working off of a certain legibility or syntax that comes from television and very mainstream drama production. What you could say absolutely about all the reference points is that they have all been very orthodox, mainstream, literary drama, but there has always been a certain ethic around trying not to get too obscure in my references, but instead trying to reference what would be considered a very bourgeois, middle-class, mainstream idea of theatre history or drama. For example, in the version of *In Repertory* I did four or five years ago in a museum space in Munich, I took a reference from a very large scale production from the Residenztheater in Munich, a grande dame of the Munich theatre scene. It was a forgotten pre-1989 Cold War reference, a Greek tragedy

production from the 1980s by the East German director Peter Hacks. I think the point is I am very interested in probing legibility and its limits. I am not an obscurantist.

YOUNG: Are you returning to the idea that narrative and signification might be possible, and you are interested in things that might be communicated?

BYRNE: I am interested in this space where signification and representation made big claims. I am interested in that kind of universal legibility, that claim of being the middle ground, being representative, and somehow transcribing an idea of the mainstream.

YOUNG: The questioning of representation in theatre has been going on for some time. Brecht in theory and practice undermines the illusionism of conventional theatre. Deconstruction and poststructuralism likewise have long critiqued representation and questioned the ability of discourse to refer to something outside of itself. Aren't you setting up a paper tiger by referring back to conventional theatre?

BYRNE: I am not working in a dialogical relationship with theatre exclusively. I have done a lot of projects that actually reference popular magazines, for example. If I am working with theatrical references, I am generally more interested in the ones that seem to occupy the mainstream or what has become accepted within this bourgeois sphere—middle-class sphere—as avant-garde.

YOUNG: Does that have a political context or political meaning for you?

BYRNE: Of course there is a political dimension, but whether it is a political dimension that's legible within the orthodox registers of the political, or what constitutes the Political, with a capital "P" is another question.

YOUNG: Of course. How would you articulate the version of the political that you are engaging with?

BYRNE: Questions around how we construct representations of our culture are political. For example, the way that bourgeois theatre constructs, say, *Waiting for Godot*, is some mythic idea of a modern subject. To me that is political as an activity. There is a politics involved in that, and at some level my work is a reflection on the contingency of that subject, and it opens out questions about the politics inclusive in the construction of that subject.

YOUNG: Much of your work is specifically oriented toward questioning that modern subjectivity, the modern self. The *Playboy* interviews which you have staged and filmed explicitly engage with the idea of minimalism and Michael Fried, and the constitution of the modern subject in that dialogue.

BYRNE: Pretty good characterization, yes.

YOUNG: I was fascinated that Fried was a jumping off point for you.

BYRNE: Essentially there is an obvious connection, which is around some idea of the theatrical that ties back to an earlier question of yours around the inheritance of performance

art. Like the project that I made recently about minimalism. There is a certain reckoning that goes on in the project with what I recognize as the precedents for my own type of practice that are less directly attached to Abramović et al. and more specifically to the modes of temporality first articulated by somebody like Fried in relation to minimalism. It's quite clear that minimalism and temporality and video art are historically interconnected.

YOUNG: Fried already makes that connection for us?

BYRNE: Yes, but in a way my project is a type of reckoning with that history.

YOUNG: How do you figure that you reckon with it?

BYRNE: It seemed to me that there was a latent potential implied in Fried's text for a film about minimalism.

YOUNG: Which you then realized in five films for the project.

BYRNE: None of which directly depict minimalist artworks. One of the films is set in a museum with an archetypal minimalist collection of minimalist art, and then we staged some areas, more scripted, more improvised. We dramatized relationships in quite an improvised way in and around both the showing of the works but also in terms of their life in the museum as art objects. For example, I spent a lot of time filming the preparators from the museum working with the objects—assembling them, disassembling them, moving them around, hanging them on walls, putting them in crates. At a filmic

level, the works become things again and there is a quotidian-ness to them. Essentially what is important is a certain filmic transcription of temporality within which these objects exist. Fried might say it is a temporality that these objects construct. Maybe that answers your earlier question about Abramović and inheritance. It is a film-based work, but there is obviously a connection to the idea of the performative in that work but maybe at a remove from the use of the body in Abramović and Vito Acconci. The bodies are still there at some level, but there is a displacement. Of course there are a lot of performers who are working in a very visceral way that very directly connects to Acconci and Abramović.

Young: Although less and less.

Byrne: You might have a better read on it than me, but I think the focus on the body is certainly there. Maybe it is on the wane, I don't know, but it seems to me there is a stubborn tradition there.

Young: I think it persists, and it is still the bias of a lot of people involved in art performance.

Byrne: Just as a small aside, I was actually in art grad school here in New York. I had friends who were studying drama or film. Somehow we would get involved with each other's projects. At some level you come to realize that you can work across and be involved in these different forms and be articulate in them.

Young: You use trained actors, as do some other artists who are pushing the performance aesthetic away from the body and

identity of the artist. What is your approach to selecting actors? Is virtuosity a part of it? What makes a good actor for you?

BYRNE: I have to say, I struggle. I think about those questions quite a lot. It is a very practical question for me and I do not have a definitive answer. I have learned a lot from actors and from watching them do what they do. I have developed a deep respect for them. But a really central kind of aspect of working creatively is what you allow yourself to do, what you allow yourself to live with, and what you find unacceptable. When I first started to work with actors, I had no background. I was a total novice. I struggled, but luckily my acting friends encouraged and pushed things along in a way on my behalf. The first actor I really worked with was my brother, who wasn't an actor, and there was a clumsiness about what he did which I realized quite early on was actually really good, really useful, really compelling. And then I made a piece in 1998 with a couple of actors, one of whom presented himself as a professional actor. The other was a friend of mine who had never acted before.

YOUNG: Which piece is it?

BYRNE: *Why It's Time for Imperial Again*. It's the piece for the Chrysler Imperial car, and by all accounts, the performances were a little shambolic. I had just started the Whitney Independent Study program at the time and was talking to established artist figures and a lot of people who basically said, "No, this is a disaster, this doesn't work." And then I had some other smart people who said to me, "This is really interesting, this is really cool. There is an edge to it precisely because it challenges our

expectations of drama and of what counts as an adequate representation." The piece was permeated with a quality of inadequacy. I had to be coached into giving myself permission to accept that as the work. And in doing that, of course, you reassemble your own set of artistic values and criteria and then you also open out to things that were not present in a previous formation.

YOUNG: This piece is distinctly focused on a kind of the postwar utopian dream about what the consumer should be in the society, what pleasures are available and prescribed. You are trying to prod the viewer into taking a critical look at that construction of the self. Would it be correct to say that the "bad" acting helps you create that critical distance?

BYRNE: Yes, absolutely. There is a type of breaking down that goes on in the work, and I think that is the unorthodox quality of the performances. It is dangerous of me to say that it has a Brechtian character because of course a lot of people have a very serious commitment to Brecht and to Brechtian theatre, and I am respectful of that in terms of its historical specificity. Allowing for that, I would claim that there is a Brechtian tone to the piece, nonetheless, insofar as you have a very palpable alienation of the tenability of the characters performed. The two characters in the piece are Lee Iacocca and Frank Sinatra, both played in an alienated manner. As mythic characters they become untenable through the work. Whatever mythic narrative surrounds them is broken down and becomes untenable and in that sense is Brechtian. It also has a certain contingent character to it that is not filmic even if the work exists in a filmic medium, a physical medium.

YOUNG: Because of this quality of imperfection?

BYRNE: This quality of imperfection: the script is repeated multiple times in different forms throughout the work.

YOUNG: There's a kind of serialism, right?

BYRNE: Yes. There is no concise encounter with it, and a lot of my other works expand that even further. Later works, like the *Playboy* works that you referenced, are shown on monitors, so not in an immersive cinematic projection space, but on monitors in the same daylight that the rest of the world exists in. The pieces are quite long, and essentially they baffle any desire to see the whole work. In that sense, actually, there is a contingency for the encounter, which is displaced onto the exhibition space and the form of the work within the exhibition space.

YOUNG: This reminds me of one of your other pieces, *An Exercise for Two Actors and One Listener*, in which two actors are doing improv and moving through a public space. The piece was perceived through a set of headphones. And the people listening through the headphones couldn't see or identify who the actors were who were speaking.

BYRNE: They mingled in the same space as their audience without ever being revealed. That piece is usually staged at the opening of exhibitions. Invariably they are group exhibitions. You usually have a confluence of a lot of different people in and around some sort of central lobby type of space and so this piece takes on a *mise-en-scène*. I have two actors who work together in this improvised manner. They are in the crowd,

totally unidentified, and they use basically what is presented in the exhibition as a series of prompts—cultural, theoretical, literary or whatever—a formation of an improvised script. Now, of course we have worked together beforehand on modes of improvisation, potential relationships with the material, but ultimately it is not scripted.

YOUNG: And these are professional actors?

BYRNE: I usually work with professional actors, but this question of professionalism in acting has got nothing to do with the quality of delivery. You might say it has more to do with the set of relationships that are established in and around the production.

YOUNG: Because of the training the actor has received?

BYRNE: No, because you pay people to do it.

YOUNG: Because of the relationship that you set up.

BYRNE: Yes. I usually work with professional actors not because I think they are better, although sometimes they are. I normally work with professional actors because if you establish a set of relationships around the production, you can be sure that people are going to show up for the shoot. It is quite important, for me, to de-differentiate between these hierarchies, between professional theatre versus non-professional theatre. It is quite important to me to not re-inscribe those hierarchies.

YOUNG: It seems that your work, both in its content or themes and in its process or methodology, is aimed at taking apart all

of those hierarchies, and the perception and the expertise of the performer. Would that be correct?

BYRNE: Yes. I am not a nihilist or an anarchist but there is a cultural process of remaking. Remaking is probably the best characterization of what cultural practice is now. An artistic practice that is reflexive, that recognizes that people who come to the performance or to the exhibition bring a history with them. You don't walk in as a blank slate.

YOUNG: And your object is to get them to question that history.

BYRNE: My object at some level involves engaging with that history. So, for example, the minimalist film, *A thing is a hole in a thing it is not*. Let's face it. Michael Fried and his debates around minimalism are pretty arcane if you are not an art historian. I showed that work at the Renaissance Society in Chicago, on a university campus. There are some visitors from the art history department of the university, but you also have a lot of students or people who are from the sciences or from other fields who like to go see art exhibitions and don't particularly know anything about Fried. I also showed the work at the gallery at Lismore Castle, which is in the middle of nowhere in Ireland. I have to think through how legible this work is within a gallery context. To what degree is it arcane and just overly particular in its set of concerns? My rationalization around those concerns was that people who go to art galleries go there to see art, what they expect art to be, which is more or less informed by art history. It seems appropriate enough to reflect on art history within that context.

YOUNG: I wonder if you would characterize this concern with legibility as being theatrical. I would describe theatre as a social medium but it does not really exist unless it is being performed and perceived.

BYRNE: Oh, yes, that is really important for my work of course. I just did a kind of survey show in a museum in Dublin. One of the things that was interesting for me was to realize the degree to which the work isn't just something that's made in, for example, a video editing suite and then burned to a DVD or whatever, and then that's the work. I have to engage with the gallery space. I have to figure out where these monitors will go. I have to figure out how people will circulate in the space. I have to figure out what type of chairs should be there. In other words, the work is spatialized at some level, and I have to engage with all those institutional, janitorial, spatial, pragmatic issues in a way that maybe other artists don't need to. It is not site-specific in that usual connotation, but there is a clear engagement with the actual spatial configuration and realization of the work that connects in a way to the idea of legibility for whatever audience that might be present there, and also in that sense expands to the relationship with the theatrical in the way that you just characterized it.

YOUNG: I think that connects to the idea of what is sculptural and what is offensive to Fried in a way.

BYRNE: Absolutely. For the *In Repertory* project that we started to talk about, all of the theatre props that I have worked with were selected because I have been interested in two qualities.

One is this quality I described earlier, which is a certain arche-typal or canonical relationship with the idea of theatre. The other quality that I have always been interested in is the degree to which these props can be understood sculpturally. This is something that was quite refined in the presentation of *In Repertory* at the Abrons theatre for Performa 11. Each of the props that we used was originally made by sculptors for theatre productions. There was a kind of hangman's noose contrap-tion at the back of the space that was designed by Noguchi for a dance piece. Noguchi famously did the Martha Graham sets but this one was for a different choreographer. There was a very abstracted large metal head, a bust that was inscribed from two profiles, a Janus-like head, that was designed originally by Barbara Hepworth for a production of a Greek tragedy at the Old Vic Theatre in London. Then the other element, which I had used several times before, was a citation of the tree that was constructed by Giacometti for a production of *Waiting for Godot* in Paris, at the Théâtre de l'Odéon. I wanted to leave open potential readings both as sculpture and as literary, theat-rical props. I am quite interested in the ways sculpture always signifies its own specificity, whereas props always signify their own genericness—they are always merely citations. The inter-esting thing, for example, about the Giacometti piece was that at the end of production it was dumped.

YOUNG: That is a very good example of the temporal aspect of theatre, which is very different from the archival mentality of the visual arts.

One question I have been asking myself about visual art-ists like you who are engaging with theatre, as opposed to the

other kind of performance art, is whether you are able to do it because you perceive theatre as a dead, archaic art form. Do you perceive it that way? And is that part of the reason you are giving yourself permission to use it?

BYRNE: I think that is one interesting way of characterizing some mutual interests. Certainly the archetypal character of mainstream theatre feels archaic, and interesting for that. As I have said previously, I am also drawn to the provisionality of theatre productions, which do not seem to be trapped in the economies around the spectacle of production that seems increasingly prevalent in the art world. Props are in that way quite interesting, for example. They have been liberated from a larger anxiety that surrounds sculptures.

YOUNG: Do you personally go to the theatre?

BYRNE: Intermittently. Less so right now as I am a relatively new parent, but it is something I really enjoy.

YOUNG: Ireland has such a strong theatre tradition. Is your attraction to it, do you think, somehow nationalistic as well?

BYRNE: I do not think it is nationalistic, in that sense. I am happy to acknowledge that my background growing up in Ireland inculcated a respect for the power or the authority of the word. Yes, I think it might be an explanation for my interest in the possibility of discourse or language to make claims of things beyond itself. That is a very central characteristic of what I am doing: whether it is those roundtable discussions from *Playboy*, the attempt to somehow articulate a *Zeitgeist* or the

way I am interrogating the tenability of the claims that I make, in a historically displaced manner, filtered through historical displacement. But I am interested in language's capacity to lay claim, to represent something beyond itself.

YOUNG: Yes, I think in that way your work is different from some visual artists I see using theatre in that you are willing to use the text for what it says. Very often the gesture is to eviscerate the text and finally there remains just the title and something vaguely described as a "reference" to something else, whereas you have actors speaking lines, whether they are rehearsed or improvised lines or taken from *Playboy* or Beckett or wherever.

BYRNE: You're right. For me there is a certain essential commitment to the form that I am working with. If my own response to it is to be taken seriously, I have to take it on for what it is.

Sounds Like Theatre

A Conversation with Janet Cardiff and George Bures Miller

While invoking theatre explicitly, visual artists allow themselves the freedom to redefine the parameters of the medium. They create alternative forms of texts and devise open-ended narrative styles. The text in the visual arts context is decentered, one piece among many that contribute to the overall experience. Likewise, in the use of space, visual artists readily disregard the architecture of theatre. They create immersive environments. Or they provide a mechanism to thrust the spectator into a new experience of the ready-made of the world around her.

Though the power of the voice has been a staple of theatre from time immemorial, since the late 1990s the Canadian partners JANET CARDIFF and GEORGE BURES MILLER have pushed the exploration of the voice and text in the visual art environment, developing soundtracks that convert the experience of an installation or real-world place into theatre. The porousness and interactive qualities of their work seek to reconfigure the relationship of the spectator to the performance. The spectator is prodded into collaboration. Though their work travels extensively internationally, it manages to maintain its theatrical power to cause a specific experience of the place where it is exhibited. They have produced audio and video walks, in which a recorded voice delivered through headphones guides individuals through the experience of a museum or other

environment. They have also created installations much like theatrical sets in which recorded sound and voice evoke a narrative. The generally fragmentary, allusive, and suggestive texts that one hears are designed to employ the mind of the listener to construct her own narrative.

As the Canadian representatives at the 49th Venice Biennale, Cardiff and Miller gained worldwide attention and won both La Biennale di Venezia Special Award and the Benesse Prize with *Paradise Institute*, an installed movie theatre with a crime scene soundtrack. They have since exhibited at major institutions and galleries in Europe, the United States, and around the world.

In 2008, the British Columbia- and Berlin-based artists created the sound installation The Murder of Crows. *Previously presented at the Hamburger Bahnhof in Berlin and other venues, it was installed in 2012 at the Park Avenue Armory, New York, at which time this interview took place by telephone. In the vast, dark Park Avenue Armory drill hall, Cardiff and Miller arranged ninety-eight speakers, each with its own soundtrack, a mixture of music and sound effects. The sound traveled around the array of speakers, acquiring a strange physicality. In the center of the enormous hall, Cardiff's voice recounted her dreams from an old-fashioned speaker horn, which rested on a table. Stylistically,* The Murder of Crows *was reminiscent of Cardiff's 2001 sound installation,* The Forty Part Motet, *which consisted of forty speakers disseminated in a space, each carrying the voice of an individual*

singer. It was included in the 2010 Lincoln Center White Light Festival and has been exhibited at MoMA PS1 and other venues around the world.

Young: Talk about your relationship to theatre, because there's definitely a theatrical element to your work. I'm thinking of *Playhouse*.

Miller: In a way I felt *The Murder of Crows* was moving away from the theatrical. It is theatrical, but we'd just done a few pieces that were even more theatrical, say, *The Killing Machine* or *Opera for a Small Room*. We used computerized lighting to move as the sound moved. With *Playhouse* we were thinking of a more simplified piece.

Cardiff: But at the same time, I think what happens is that we have a certain relationship with the audience that turns them into being a spectator.

Miller: A theatrical spectator.

Cardiff: Which is very much like in the theatrical world. Even with the video walks. We just finished a video walk in Kassel: *FOREST (for a thousand years…)*, in dOCUMENTA (13). It's nighttime. It's like theatre. You're watching different actions happen in different places as you go through a different space. So I think we have a really strong dialogue with contemporary theatre and dance in a lot of what we do.

Miller: We're frustrated with theatre. We're trying to immerse the audience in some way that you can't do in theatre. In

theatre, there's always a line between you and the stage. It's hard for it to be an immersive medium, whereas with sound, when the viewers close their eyes, they can be in a different world than you can be in the theatre.

YOUNG: *The Murder of Crows* seems to take a different relationship to the audience than the audio walks, for example, which are more directed, in terms of how they speak to the audience member or spectator, kind of controlling or directing the choices that are made.

CARDIFF: Yes, and I think it takes a different relationship than, say, takes place in *The Forty Part Motet*, which is a piece in a similar vein. The audience is not necessarily directed to sit down, but the whole concept of the piece is that when they move around it's a different piece of music for everyone, whereas with *The Murder of Crows* we were more interested in the sound moving around the audience. They stay mainly in the sweet spot, we call it, and then we have the sound moving from one end of the space to the other end of the space.

MILLER: And in that way it's very different from the walks, because the viewer is moving and the sound is always with them in their headphones, but here we wanted them almost in a sound booth, a sound environment.

CARDIFF: We just like working in a lot of different ways too. With the walks, we love to have the physical reality and the virtual reality lined up. There is this strange interaction that happens.

MILLER: Quite often synchronistic events happen in that situation with the walks. They are a very different form of work. We're always trying to do something new and change. We've wanted to do something similar to *The Forty Part Motet* where you just use speakers, and it's a fairly simple setup, just using the sounds to move people around. That was a problem we set ourselves.

YOUNG: In *The Murder of Crows* at the Armory, I found it disturbing that there were chairs in the environment, because my instinct was to walk around.

MILLER: If you're asking the audience to stay for thirty minutes in the same spot, we're not against providing some comfort for them.

CARDIFF: Back to your question about theatre, I saw it as a bit of a set. Years ago we saw a piece in Berlin, a reworking of Beckett's play *Krapp's Last Tape*, and in ways there are many of our pieces that reference that work, where there is a single performer on stage recalling something. So for me it's a piece where the audience can sit there and there's a symphony around them. In theatre, the symphony is in the pit, whereas with this one the symphony is around them, so it definitely does reference traditional theatrical setups. Like *Opera for a Small Room*.

MILLER: Which is very theatrically based. It's a set basically in the middle of the gallery space, a room filled with records and record players, and you hear a voice coming out of a megaphone and the lights move and the sounds move.

YOUNG: I had seen a similar piece at a group show at Luhring Augustine Gallery in Chelsea, where there were telephones. It was called *Dreams—Telephone Series*.

CARDIFF: You're right. They came from the same place. Those dreams that we used for the telephones were recorded in Kathmandu at the same time we recorded the other dreams. We didn't realize we were going to use the dreams for *The Murder of Crows* until later, but they come from that period.

MILLER: We were recording our dreams at night, so those dreams from the piece are actually recorded at the bedside, which gives it that feeling of....

CARDIFF: Somnambulism.

MILLER: So if there's a sleepwalking tone to her voice, it's because she basically is sleeping.

YOUNG: That is what I inferred; otherwise, you're a great actress.

CARDIFF: No, I'm not a great actress.

YOUNG: In taking up that practice, were you deliberately referring to Freudian theory? Freud counseled his patients to write down their dreams immediately upon waking so as to have their freshest impressions.

CARDIFF: Well, with the telephone series we were definitely referencing Freud because the telephone was from a similar era.

MILLER: From the thirties anyway.

CARDIFF: Yes, you know, one of those telephones sitting on Freud's desk. So I think you definitely picked up on that reference. I can't remember at what point we were researching dreams, and of course that Goya image [*The Sleep of Reason Produces Monsters*] came up and some other stuff, and reading about Freud and the recording of dreams—that all came into it, but nothing is very direct. Although the horn is a direct reference to the etching: we see him lying on the table and all the crazy monsters are behind him and you can't wake him up.

YOUNG: The brochure for *The Murder of Crows* at the Park Avenue Armory says, "The piece is a requiem to a world of positivity and utopia that—although heralded at the end of the cold war after 1989—seems to have disappeared in our time of pathological 'war on terror' and 'ethnocidal' violence that mark the darker side of globalization."

MILLER: We were making this piece in the dark days of the Iraq War. It was the most depressing time.

CARDIFF: We started the piece in 2006.

MILLER: Or earlier than that. We just respond to what's going on in the world, so it has a dark tone to it. When we were making it we were thinking of it as a reaction to that time. I have said it was a requiem for the previous age. After 9/11 everything changed so radically in a way, and maybe it really didn't, but it did in the mind or in the media.

CARDIFF: I think it refers to the war in Iraq because when we started the piece we were getting the *Herald Tribune* pretty

regularly and there were always these horrific articles about what was going on, and for the international version, more than the domestic version, there'd be more from the Iraqi side of things. One of the articles that was particularly inspiring was about a father who came home one day to find that his house had been blown up and his three daughters had been killed, and one of their arms was just hanging from the chandelier. The idea that there are people stuck in a situation and they can't change it. An ordinary person has their family killed and has no ability to do anything about it. They're powerless. So it's a lot about the Goya series, and I think we were in a situation in Kathmandu where I was having nightmares and the helpless feelings of being in the dream.

MILLER: You couldn't tie it to the piece directly. It moves subconsciously like a dream in a way, and that's what we wanted the piece to have.

CARDIFF: One reviewer talked about the horn as a reference to *1984*, the George Orwell novel. I actually reread that novel when we were producing the piece, and I kept saying that this is just like the media now. Who is the U.S. at war with now? Which power are we at war with now? It's very *1984*.

YOUNG: The other thing that I noticed about this piece, and it did remind me of *The Forty Part Motet*, is the prevalence of music.

CARDIFF: We were reading books about the emotional impact of music, how music connects to you on a subconscious level.

Sounds Like Theatre

YOUNG: Thank you so much for your time. I kr
traveling.

CARDIFF: We're in Ontario, visiting my parent

YOUNG: I'm in San Francisco myself.

CARDIFF: I remember someone told me
is up at the San Francisco Museum of I
Time Telephone.

YOUNG: Is it part of the show on theatri
Presence?

MILLER: Yes.

YOUNG: I'm going to see that this afternoon.

CARDIFF: Then don't miss our audio walk there. They're chang-
ing the building so much that it might be the last time to see
it. We are hoping that they can reconfigure it, but we don't
know yet.

Sounds Like Theatre

One of the problems we set ourselves was this idea
can move people without visuals. How do you move
How do you make a film soundtrack? And of course mus
big part of that. So we collaborated with a composer in Berlin
and we also used a composition by a Montreal composer, Fre-
ida Abran, for an electronic section. And then we worked with
the composer Tilman Ritter for the operatic section. We gave
him the words for the libretto and a lot of suggestions.

MILLER: He's a film composer so he's used to working
collaboratively.

CARDIFF: We always wanted to do a big guitar sequence, so we
invited a lot of guitarists to our studio out west and we started
working like that. Mainly, in the way the *Motet* separates the
singers, we wanted to take apart an orchestra and take apart
different instruments and have them move through the space
but also just have some of them located in different parts of the
space. That's why we also use the Russian choir coming in. Of
course it also has its subtext.

YOUNG: Do you consider yourself to be a writer?

CARDIFF: No. That's a short answer isn't it?

YOUNG: There is a lot of text in your pieces.

CARDIFF: I think at one point I was interested in writing a
novel. About fifteen years ago I started, but I realized that I'm
not a very good writer at all. The types of writers that I admire,
I could never be. But I think the form we end up working in

some writ...
ggering people's idea...
scenes. We're able to comple...
effects and, in the case of the video walks,

MILLER: In *The Murder of Crows* we'd been building all these seeds with narrative and then—we'd been building all these seeds with the music and sound effects—we felt that we weren't getting enough from all that, that we needed to add something else.

CARDIFF: Some structure.

MILLER: To give people a more coherent image in their minds. We'd recorded the dreams, and these dreams we chose fit very nicely with the music and sound effects that we'd already been working on. They gave it this kind of structure and filled it in. The sound effects and the music weren't doing what we wanted the piece to do. It needed something else. It's interesting because the Kassel piece, *FOREST (for a thousand years...)*, has no vocal narrative.

CARDIFF: But it also has the beautiful forest to sit in, so it has the visuals. It could be a film basically. There's a bomb sequence, and we even have a monster scene in it. Usually we like to have a funny part, but I'd say *Murder* isn't so comical.

MILLER: But there's the aria part. The music for that is almost like Queen. We were trying to reference *Wayne's World* where they're singing *Bohemian Rhapsody* in the car. Well, no I'm not going to go off on that track.

Scripts and Process

A Conversation with Pablo Helguera, Ohad Meromi, and Xaviera Simmons

Visual artists have found many ways to appropriate and repurpose theatre and its practices, and in doing so have created powerful synergies that produce thoughtful, boundary-defying work. One approach is to look at theatre as process. Rather than fixating on the endpoint of the performance or the completed work of art, artists look at the interim steps in the creative collaboration. This approach reflects the art world trend favoring the unfinished work. It allows artists to play with theatrical ephemera and open up alternative perspectives on theatre. For some, the process is the endpoint, as they look at art as a conjuring of community and a live place to work. As the twenty-first century rolls on and revolutions around the world put the system to the test, theatre may be one way of creating a dialogue about what society ought to be. Participatory theatre and performance can be a means of eliminating boundaries and effecting political healing. On the other hand, forced participation is coercive and leads to a loss of independence in thinking and action.

Theories of theatre have become wellsprings of making art. Artists have looked to the biomechanics of Russian constructivist Vsevolod Meyerhold, the method acting derived from Konstantin Stanislavsky, and Sanford Meisner's technique, which involves training by repetition to be in the moment. The

theories of Bertolt Brecht as he expounded them in the *Lehrstücke* propose eliminating the audience and moving toward a participatory model of performance. Augusto Boal, the Brazilian theatre artist and philosopher, has caught the attention of socially engaged artists who turn to his well-known book, *Theatre of the Oppressed*, for a disciplined critique of traditional theatre and inspiration in ways of using theatre to foment social progress.

Some visual artists have wholeheartedly embraced specific aspects of traditional theatre in order to create their work. For them, the architecture of the theatre, rather than being viewed as a defect, becomes a starting point for confronting the spectator/performer division. The stage set, when presented as art, becomes a space that is activated by the imagination and actions of the audience. Though most artists would rather ransack the Internet and the canon of dramatic literature for scripts that can be appropriated, some go so far as to write plays and stage them with professional actors. Some artists, in learning to use theatre, have even undergone acting training.

Pablo Helguera, Ohad Meromi, and Xaviera Simmons have all taken theatre into their art in these ways. In doing so, they show how theatre can change art performance, photography, and sculpture.

PABLO HELGUERA, born in Mexico City, is a New York–based artist working with installation, sculpture, photography, drawing, and performance. He has written plays and staged them in various kinds of visual arts institutions. His *The School of Panamerican Unrest* was a nomadic think tank that traveled from Anchorage, Alaska to Tierra del Fuego. Helguera has

exhibited or performed at MoMA, New York; Museo de Arte Reina Sofia, Madrid; ICA, Boston; RCA, London; MoMA PS1, New York; Brooklyn Museum; HAU, Berlin; and The Kitchen, New York, among other venues. He is the author of several books, including *Theatrum Anatomicum* (2009), a collection of scripts for lecture performances, and *Alternative Time and Instant Audience* (2010), concerning alternative spaces for performance and exhibition in the art world.

Born in Israel, OHAD MEROMI lives and works in New York City. Meromi's work combines sculpture, architecture, installation, and performance. He has created theatrical play spaces and appropriated classical theatre texts. Two of his exhibitions drew upon Euripides' play, *Cyclops*, developing platforms for potential performances and props related to the text. He graduated from Bezalel Academy and received his MFA from Columbia University School of the Arts. He has exhibited at The Israel Museum, Jerusalem; The Tel Aviv Museum of Contemporary Art, Israel; CCS Bard, New York; Serpentine Gallery, London; the 2007 Lyon Biennial, France; Magasin 3, Stockholm; De Appel Museum, Amsterdam; the 14th Sculpture Biennial, Carrara; Sculpture Center, New York; and MoMA PS1, New York.

XAVIERA SIMMONS was born in New York City and lives and works in Williamsburg, Brooklyn. She makes photography, performance, sculpture, installation, and audio and video work. Xaviera received a BFA in photography from Bard College in 2004 after spending two years on a walking pilgrimage with Buddhist monks, retracing the Transatlantic Slave Trade. In 2011, she re-performed George Brecht's *Motor Vehicle Sundown*, an outdoor performance involving several automobiles.

She completed the Whitney Museum of American Art's Independent Study Program in Studio Art and a two-year actor-training conservatory with The Maggie Flanigan Studio. Major exhibitions and performances include the Museum of Modern Art; *Greater New York* at MoMA PS1; the Studio Museum in Harlem; Contemporary Arts Museum, Houston; and the Sculpture Center, New York.

On April 20, 2011, at Location One in New York City, these artists discussed their engagement with theatre.

YOUNG: The division between theatre and the visual arts is strong and persistent. I recently went to a panel sponsored by Performa called "Staging Language." I expected that theatre would be part of the discussion, but consistent with the way that performance theory is understood currently, the word theatre was mentioned once during the course of the two-hour discussion. Similarly, the February 2011 Issue of *Artforum* celebrating collaboration as a contemporary way of making art referred to the prototype of film production, rather than theatre, and noted, "It is not surprising that film as an inherently collaborative mode of production features prominently as a way of collective art-making from the margins." As if theatre hadn't been a collaborative process for 2,500 years. Theatre continues to be excluded from the dialogue. But there are artists like the people on our panel who are using theatre profitably to create a very interesting friction. These artists are not alone. The Guggenheim Museum is staging a nineteenth-century play,

Arthur Schnitzler's *La Ronde*. Also Sean Kelly Gallery is currently showing a Joseph Kosuth exhibition based on texts by Samuel Beckett, embracing one of the prominent playwrights of the twentieth century, of course in an unconventional way.

One way that theatre is being used by many artists and by some of the artists on the panel is what I would call theatre as process: there is not a play being staged but a reference to or use of theatrical techniques in arriving at the creation of the work of art. We'll have the chance tonight to hear our panelists talk about their work and its relationship to theatre, what it is that motivates them to use theatre, what obstacles that creates, and how it may shape their understanding of how performance works and the kind of visual art that they are creating. Let's turn first to Xaviera Simmons, who studied acting as part of her education. Could you first tell us about your training as an actor?

SIMMONS: I think every child in New York is an actor. It's a kid thing to do here. But I started formally studying at Bard College, and then subsequently, while I was in the Whitney Independent Study Program in 2005, I was doing simultaneously a two-year master's with the Maggie Flanigan Studio. Maggie teaches primarily a Meisner-based method acting course.

YOUNG: Could I interrupt to ask you to explain what Meisner is? I have a little experience with it as actors standing in a room and one of them says, "I am wearing a black sweater." And the other one says back to him, "You are wearing a black sweater." And then they repeat that endlessly.

SIMMONS: The main thing that I got out of my Meisner train-ing, my time with Maggie, has to do with living truthfully in the moment. Also repetition: you spend a full year repeating what you've heard, exactly how Paul did it. You don't really do scene work the first year of a Meisner program, or at Maggie's. You do a lot of repetition so you're fully in the moment with that person that you are engaging with. That's sort of the long story short. I didn't study acting to become an actor per se. I studied acting to be a better director. When I was studying at Bard with An My Lê, my professor, and I started making photographs with myself, using my body in the work, she said to me one time, you've really got to make your characters more believable than that. And I took her seriously. The only way I'm going to make the characters believable is if I train to be an actor. So I did, but with the intention to direct, not go on cast-ing calls and the traditional actor route. What I learned study-ing with Maggie is how to use my body but also how to use emotions. I don't want to say manipulate but in a way I learned how to manipulate a situation so that it would be the most honest in the moment. I do a lot of different types of work. I make performance pieces and I also make photographs where I do open air photographic studios and I give free portraits to passersby. Every time I work on that project, I think about my actor training because I'm able to engage people really quickly and also I am able to have my hand—almost like a sculptor. I meet someone and I can calm them in a matter of minutes most of the time. Then I can get them involved in the activity or the action that needs to happen for the photograph to be made.

YOUNG: You say that using the acting technique in making the photographs has allowed you to create a character in a dramaturgical sense. Could you explain that?

SIMMONS: A lot of the time my body will be in the work or I am technically the actor in the work. While the main story for me has to do with a historical narrative and then how the historical narrative relates to the landscape, when there is an actual figure in the landscape, and if it's my body—and I don't consider them self-portraits, I consider them characters—each image, each figure in the photograph is a different character. I try to respond to the landscape so that the character embodies the essence of that landscape in that moment, and I try to be as truthful as I can be to the essence underneath that landscape. This is just a side note. I spent two years on a walking pilgrimage, retracing the transatlantic slave trade. I walked the Eastern Seaboard, the Caribbean, and then the western seaboard of Africa, and as a result I have a really keen eye for what's underneath landscapes. I've been to slave ports, or plantations, and there is always this idea of characters that lived underneath that landscape or that grew those landscapes. I am always trying to connect to those different characters in my work. When I make the photographs, I generally bring an assistant and props and as many things as I can to construct a new character in the landscape because if I went in the landscape just as myself then everyone would always assume that it is a self-portrait about some relationship I had to the landscape. I try to make characters that are strong enough to hold the space of the landscape.

Young: Gertrude Stein and other theatre theorists have talked about theatre as landscape. I find it interesting to think about you using this acting technique in order to create the character in landscape. Is that something you've thought about?

Simmons: I've read a good amount of Stein but I don't think that she is my main key. My main key is more like Tennessee Williams or August Wilson, really traditional playwrights, and how they construct characters, and how they use language so clearly to make a character come to life. I write out every single character that I create and I write out the landscape as well.

Young: You mean, you write a backstory for the character?

Simmons: Yes, a backstory. I also write out the way the image is going to look. I don't sketch—I mean, I sketch by writing. So it's really traditional playwriting that I am thinking about. Stein is more avant-garde than what I am in my work.

Young: In creating your photographs, how does the Meisner technique come into play? You have described it as a way for actors to engage in a very live way with each other, but in some of your photographs you are a solo performer, if you will.

Simmons: I am making the photographs and I am also the actor in the photographs. I have to be in two conversations at once. I have to remember what I want the actual image to look like and how I want the image to feel at the end of the day. I have to have action that is truthful and believable in the moment. The main thing with Meisner or any actor training is to make conscious choices, to be able to commit to those

choices all the way through—that I believe my story, and that I try to believe the story as I'm making the work. It's about bringing all the props and the tools that are necessary to make the character believable. There is that famous book, [Konstantin Stanislavsky's] *An Actor Prepares*, and it is the most basic statement, but it really helps me with my photographs, or if I am doing a theatre piece, or making music or whatever. It involves remembering every single thing I need to make this piece truthful and clear and honest.

A project that I have done for the past three or four years is the *Free Portrait* series. For this project I take a backdrop and set it up in a really busy urban street and offer pedestrians free portraits. This is a prime example of using that Meisner technique, using it not so much as an actor but as a director, being able to have my hands direct the participants, to help them to calm down enough and help myself to calm down enough because they're strangers, and then get them engaged. I've probably made about 500 portraits that I have sent to each participant. In this project they are very staged and straightforward. In another project, which I produced with the Public Art Fund in 2008, instead of having the passersby be in a staged, enclosed environment, I wanted them to engage with the landscape. So, thank god for my Meisner training, because that helped me with patience and activating the participants and getting them emotionally ready. The *Free Portrait* photographs were all done in the Bronx. The participants were all strangers, and sometimes I would inject my own self in to engage with the passersby. The thing tying in the acting technique is the repetition. To get the image, I'm like, "Do it again, do it again."

I am pushing strangers on the street to make this action happen and to make it as truthful as possible.

YOUNG: A different technique, which Ohad uses, is the Meyerhold theory. This is another example of a visual artist using theatre as process. Ohad, could you first perhaps tell us who Meyerhold is and how you employ his theory in your work.

MEROMI: It is awkward for me to talk about theatre because I am not coming from theatre at all, but I found myself flirting with theatre ideas. I would be the last person to give a good answer on who Meyerhold is or anything that has to do with the serious theory. I got to Meyerhold because I was interested in Russian constructivism, the twenties and thirties, art that is übercommitted to an ideology. At that moment ideologies and art had a very impressive relationship which, viewed from this point in time, seems very inspiring to me. I'm not an architect, I'm a sculptor—but I am interested in places, a little bit like Xaviera's project where she went outside and set up this ad hoc stage and by that she somehow transformed a social situation. This is the classic inspiration moment for me. Like an architect, I am interested in what designates a space as a stage. And then what a stage is able to do. What can you do there that you cannot do in other places? How does it alter the relationship between people? I am not so much interested in what you do in the space but very interested in that moment of transformation, how one space becomes another. Hence I am less interested in the tradition of theatre or the building that has always been there, though I am fascinated with there being a place in the city that is designated for this type of activity, this open,

weird ritual. Like an architect I am using these tools that make this possible, this basic split between audience and stage, and what it does. And there are other things: you put a camera in and you automatically have a performative situation.

I want to talk specifically about the project that I recently finished, not far from here, at Art in General. It was my recent attempt to try to create a space that is in conversation with theatre. At Harris Lieberman Gallery I built an installation that I thought of as a stage set which you can inhabit and walk through. I was thinking about the process of viewing the work as a moment of walking through a set and the type of interaction you can have with an object. The story of this particular set was a series of rooms that are planned for the life of a community. There was a room for sleeping together, not necessarily a sexual type of sleeping together but sharing the room, like kids, sharing clothes. There was a room for culture. There was a room designated for outfits. There was a room designated for architecture. It was partly informed by memories of my grandparents in a kibbutz in Israel but also very general ideas about utopias, the whole idea of community, and then being in a set that deals with the creation of a community: how does architecture create a community?

Theatre is one of those potent communities. I'm very interested in the idea of a set and being inside a set, physically walking through a fiction. As an actor you can do something: when the world is a story you know you can change it, you can change a story. I am interested in this perspective from the stage outwards. There are a lot of stage objects that I have been thinking about. This is the starting point for the Art in General

project which was called *Dark Space Containing Athletes Performing Repetitive Tasks*. I divided the space into as many spaces as possible. As an architect that's the best trick, to create these hierarchies between spaces and anticipation before and after. The main space was painted black and was a rehearsal room. I was not interested in the finished performance. I was interested in some space where you could do some activity of play. There was another space in the back that was another variation. And then I introduced this pamphlet, which was a take on the Augusto Boal exercise book, *Theatre of the Oppressed*, as a proposition of what could happen in this space. As an architect, great, I set up the space, I set up the stage, but what do you do there? How do you deal with time? So there is a set of ways of going about the actual activity that happens in the space. Meyerhold is one of them. He comes up with all the biomechanical exercises and how to deal with, how to train an actor, and I thought I'll just pick and steal some of these exercises as a kind of workshop for quitting smoking. Smoking is usually my perfect action. You set up a stage. You set up a camera. There is an audience. But what do you do? You smoke a cigarette. It is a non-action which is perfect for filling that space. And then there are non-smoking exercises. I open it to the public a few times. Then I have invited friends to use that space to come up with their own interactions, and I called these spaces "rehearsal sculptures." So once you were there, there was no audience. There was just participating in this experiment of setting up an ad hoc social interaction.

YOUNG: Xaviera uses theatre as a means to an end, but for you, Ohad, the theatre process, the rehearsal process, is really an end

in itself. Being in that rehearsal is the reason that you construct these spaces and invite people in and create these exercises, so they can have a live experience.

MEROMI: In a way, yes, it's like a bone soup: you cook the bone and then you take it out. It's about being, inhabiting the space. How do I inhabit the space of theatre and what does it mean to inhabit there? In a way you need a script and an action. Yes, it is an end in itself. Or it is an object of observation. I don't know if this is an end. It creates something that may qualify to be called theatre. Then I look at it from inside and try to take some of its potency and use it in some way.

YOUNG: For you the incompleteness is very important. In an interview you said, "If it's finished, it's dead." You don't want it to be over. You want it to be incomplete.

MEROMI: I am interested in the theatre and the rehearsal space. Not coming from theatre, I am super self-conscious, so the idea of having an audience watch you almost kills the whole thing. I am trying to play with the situation. Can you get rid of the audience? I am doing a trick. I split it. So there will be an audience, and then I get rid of the audience. I am getting to participation, but I am not so interested in the performance. I am interested in the perspective from the stage. Can we be actors on the stage and look out and use the situation? This is the sensibility. Being inside the stage, I have to find ways of getting in there without the spectacle. I am not interested in the spectacle.

YOUNG: You derived the idea of participating in the acting from Brecht and the *Lehrstücke*. In connection with this certain set of his early plays, he wrote that participating in acting in the plays could be an end in itself, and that he did not need an audience for these works.

MEROMI: I was building sets, then using the studio. I work a lot with models, and then I come to this problem. What do I do in this space? Then I thought maybe I would use an existing script. I stumbled on the Brecht "learning" plays, which were perfect because he says that acting the plays is the educational experience. In his lifetime, they were always performed traditionally, but he presents that as a mode of work. This is his original note, a model of participation, which is later on switched into his other option in which there is no participation, but a different mode of spectatorship.

YOUNG: Let's enlarge our discussion to include our third member, Pablo Helguera. Pablo, you jump into theatre with both feet. You don't disdain the idea of using performers, actors, or scripts. If anything, among the three of you, your work most closely resembles a theatre practice. You are unafraid of embracing that.

HELGUERA: In art school I hated performance. I had to take a performance class and I hated it. I thought it was ridiculous. Toward the end of my student years I embraced it in a very fervent way. I realized I was interested in bringing together writing, images, and action, and the only way I could find to do that was performance. Then I was in graduate school at the

Art Institute of Chicago, and it was basically a bad situation for artists. There was nowhere to show; however, Chicago has a very strong theatre tradition. Second City, Steppenwolf, the Goodman Theatre, and lots of alternative spaces were devoted to performance. So my theatre education was more in the street, in the neighborhoods where we were doing this community theatre basically. And because we weren't able to show, we were just doing these performance evenings, all-night performances, and one of the first evolved for me and became a play. I started writing plays in the nineties, and then I started working in museums and museum education and that continued in a separate way. Then I realized that there were all kinds of performances going on within our institutions which were things like this, panel discussions.

My job for many years has been to organize panel discussions just like this, and I eventually became frustrated with how bad they were, how most people in the art world had a hard time engaging the public in person and articulating their ideas. Then I started asking myself, wouldn't it be great if panel discussions were actually plays? If we have directors for plays, why not dramaturgs for our lectures? So I decided that I would try to do that. And then I wouldn't really tell people that it was happening because I realized that when you announce that you are going to do a play, the expectations are very different than for a lecture about art. I started composing symposia and panels with actors that were completely scripted, but we did not tell the audience that it was a play or a panel. In fact, there were many panels that I organized that were really plays. So part of the test was to see if you could insert that fiction in reality and

still maintain the tenuous line between what you think is real and something structured as an art piece.

In Kansas City, we produced a retrospective of a fictional artist whose name was Juvenal Merst. We produced all the works of this artist and all the educational materials, catalogues, etc. We claimed that the artist had died around seven years ago and that he was a very important artist in the nineties who was unjustly forgotten. We brought a group of people who were his friends at the time to be part of a symposium recollecting his life. We did an opening with all of his acquaintances there. We inserted the actors in the Kansas City art scene. And then we had the formal event which was like this, a panel. The characters include a critic called Sonja Stillman, who wrote about Juvenal's work throughout his entire career; a woman named Rosario Palvariso, who was a collector of his works; and then the girlfriend and the boyfriend, because he had different phases; and the moderator was an art consultant who benefited a lot from the sales of his pieces. They start talking about Juvenal Merst, going through an art historical discussion of his works. Pretty soon no one seems to agree on anything. Was he a minimalist? Was he a socialist? Was he gay? Was he straight? In a way it was a fiasco. He was a false artist, and they were going to participate in creating his falsehood. It was really a play about how these people have lost their way, but they had implicated themselves in the construction of an artist that they had to support.

YOUNG: You hired professional actors to perform, and you took the actors to openings and other events, so they could observe people in the art world.

HELGUERA: When I was casting the play, I tried to cast people who knew the art world, and that was a bad idea. They were too self-conscious about portraying these people. And so I went for people who knew nothing about art. Absolutely nothing. I gave them a crash course on contemporary art. We spoke about minimalism. The whole history. It was fascinating to see them discover us, coming to panel discussions like this and seeing how people's bodies moved, and eventually morphing—because they were very good actors—into beings that were so realistic. It was a very difficult leap to make because, not only did they need to exist in the structured environment on the panel, but they also had to exist in the unstructured environment of the opening, where we had them walking around and looking at the exhibition and saying things like, "What do you like?" Very open-ended questions that you had to answer.

YOUNG: This is kind of a metatheatrical moment, to invoke the fake panel at the real panel. I want to switch to a completely different part of your practice, and one that I think ties the three of you together, namely the idea of participatory theatre and some related ideas about community and politics. I'll start with you, Pablo. You've just come back from Italy where you won the Emilia-Romano Prize in Participatory Art. Tell us about that.

HELGUERA: I have worked in museum education for twenty years. And I performed for that period of time as well, so I am constantly thinking of how you use theatrical processes to teach, at the same time that you perform. It goes hand in hand. Theatre is the possibility of sociability and attaining a certain

consciousness. Whenever I teach art students, I think about social practice. I try to emphasize those two things.

YOUNG: Xaviera, participatory theatre and the idea of community are also important parts of your work.

SIMMONS: In a piece called *Junctures (transmissions to)*, I built a room that the audience couldn't see into. They could hear everything that was going on, through speakers that were outside the room, but you couldn't see the participants. You'd hear them, and you'd see them putting out information. We would make a photocopy of an image or write out a text, and then we'd bring it outside to the audience and leave it on pedestals. We would show a video projected out of the room and into the space. I would imagine being frustrated because they are hearing all of these things, but they are only able to experience this half, awkward performance. It's interesting, sort of in between you two.

YOUNG: Ohad, obviously participatory theatre is extremely important to your practice.

MEROMI: Participation is really interesting, but I am also afraid of participation because there is something really problematic about this moment when the audience starts to participate. I am interested in theatre because of the idea of agency, to find it and use it, the reality of it, like the politics of the theatre. But there is that horrible moment when the clown goes down from the stage and breaks through this barrier and drags you to the stage. A forced participation is the worst thing ever. Ideally

we want all to share this potent fluidity of identity that the stage allows for. But that is not something that can happen instantly and I think that is a thing that one should be really cautious about, even though it is a moment of participation. We all want to be interactive and click. We have to remember all of the things that we are missing when we click a page. That means we are never staying in that page. Are we really that much more active when we are writing the story or when we are reading and there is an author and there is a relationship between us? I'm talking about reading as a metaphor here: using our imagination to fill in the gaps or to come up with a story or to fill the words with images. We are giving all that away when we are forced into automatic participation.

SIMMONS: That makes me think of going to a museum and bringing your camera. I was at the Met yesterday looking at the Richard Serra show, and I noticed that everyone had their cameras. Everybody's making photographs of art. They are having an experience but they are not even looking at the actual image in front of them. They are making a photograph, collecting for later on—you are not really engaged in the moment because you are so focused on what you can take out of that moment.

YOUNG: Coercion is an interesting issue. In the American theatre tradition, as it developed in the sixties and seventies, participatory theatre had a strong political base. The social revolution was taking place—sexual liberation, gay liberation, the women's movement, the civil rights movement. There was an identification of popular uprising with participatory theatre, the theatre analogue of the social revolution. My feeling toward

participatory theatre is that I fear coercion as an art fascism. Do you have that sense or is it something that you think about? It seems to be an issue for you, Ohad, when the clown comes off the stage and forces everybody to participate.

MEROMI: Yes, because it is a delicate issue. I am obviously interested in creating mobility.

HELGUERA: I think that comes from Xaviera's conception of what participation actually means. It comes from this notion that you are going to impose something on the audience instead of creating conditions for the audience to freely choose to engage in the work. You can certainly create a context where the moment people take a step they know that they are engaging. Yes, I agree, when you attack an audience, it is not very productive because you are scaring them away. However, I have been criticized many times for doing precisely that.

MEROMI: Same here. Me, too.

HELGUERA: Maybe we all have. In the case of these works, the fact that you are not saying, "This is a play," it is kind of manipulating.

MEROMI: It is manipulative.

HELGUERA: It is dishonest because you are not telling us what it is. But to me it is a very necessary price to pay if you want to address a particular set of issues. The moment that I say, "Hello, welcome to a play," I am already framing, saying, "Look at the frame of this work," which also creates the possibility for

people to say, "Oh, it's just a play, it's not part of this particular moment." Sometimes situations call for eliminating the frames and then creating the situation that you simply have to live with. I agree, there are subtleties. It is very important to the artist how you manage it. It really becomes more of a social choreography where you do not completely alienate the audience but you also are not completely subservient. You don't serve everything on a silver plate.

SIMMONS: For the *Free Portrait* series, I don't speak about the politics of where I am shooting and which people I am producing this work for. I just make the work, but the politics are right there. If the audience spends five minutes looking at it, they're going to see the politics inherent in the body of work. I don't feel like I need to spoon-feed the audience the entire structure for them to understand the mechanics of the play, if you want to call it that.

MEROMI: I think the model of education that you use, Pablo, is a useful one, and you, Xaviera, talk about negotiating with people, and I think it's a lot about that. If you negotiate correctly with the people you are working with, there's possibility there. What I am interested in isn't spectacle or the performance side. I am interested in the environment, the social situation. I am interested in working together and creating a work environment. I prefer to call my pieces workshops rather than performances, so that has to be some sort of room. And I understand what you are doing, Pablo, but for my purposes it is more important to have a long conversation before we start, and to figure it out, define our limitations and set of rules for

what we are doing for this particular time. And then it is open for participation and can be a really potent, amazing tool.

YOUNG: Ohad, participatory theatre does have fairly explicit political connections for you in your experience in a kibbutz. I read an interview in which you talked about the decay of various political philosophies during the twentieth century. You believe that your art is a path to find a new way of social being and political participation.

MEROMI: These are such huge hopes. Yes, I have utopian thinking, and I really want, when I'm making an artwork or a social piece, that this is somehow in the horizon of what we are doing. So how can we have a conversation that goes there? Can I do a little laboratory, a little model, to think about these models that we have inherited from the history of theatre and the history of art? Can I understand them and maybe revisit those models and use them, and maybe invite people to think about them together? I try to create environments to think about these questions together and talk about our hopes. Maybe theatre is a good place to discuss our hopes about what type of society we could be.

YOUNG: My catchphrase is, theatre as a social medium. That seems to be the way you are using it, as a mode of engagement to talk about things. I think it is similar for you, Pablo.

HELGUERA: I learned a lot from existing theatrical traditions. In fact, I am actually very interested in traditional theatre, which is odd coming from contemporary art. We are maybe more

involved with the idea of theatre than making theatre. But I
love Tennessee Williams's plays. I like the atmosphere that the
traditional theatre creates. My play about the fictional artist
Juvenal Merst becomes a very Tennessee Williams play where
there is catharsis; they were all crying at the end. But it felt like
a necessary search. We needed ourselves to find out who are we
and what are we doing.

YOUNG: Let me make a broad generalization, and then please
correct me. It is true for both Xaviera and Ohad that in your
engagement with theatrical practices you separate the language
and eviscerate the text. Ohad, in performance, you eliminate
the text of Brecht's *Lehrstück*. In the same way, you turn the
Euripides play *Cyclops* into a wordless performance. Similarly,
Xaviera, in your photographs, there is no use of language,
although I'm aware that it appears in other parts of your prac-
tice that are not so overtly connected to theatre. Whereas, you,
Pablo, seem to have a very direct relationship to language and
writing and performing, different from the way Xaviera and
Ohad are approaching them.

SIMMONS: With plays, the language is so intentional. Every
word matters for me when I am reading a play because it's the
only thing that you have to hold onto to engage the characters
and construct the language that you are living in. I think earlier
you were referring to sculptures I've made or even the snippets
of characters that come as a result of the photographs: they are
really all about the smallest moment, the smallest part of lan-
guage, how one word can open up a whole dialogue of possible
conversation, or one word can open up character. When I read

plays I usually read them in one sitting, and I am trying to let every part of the language soak into me so that I can use it in the photographs or the sculptures. Besides poets, playwrights get it best because they are able to concentrate and distill an emotion in a moment, in a sentence, in a word.

HELGUERA: One of the things that I really believe is that every artwork is a script.

SIMMONS: Yes.

HELGUERA: And that we produce a work based on a series of conceptual observations. There is Sol LeWitt: if there is a shape A, then B. That to me is a script. Theatre is a natural way to explore that. Everything that I do I see as a script. It doesn't matter if it's a closed system or open-ended, a social situation. People are going to come, and they're going to interact—that is an open section of the script—but then it closes again. Theatre allows us that, and for that matter music as well. If you come from a musical tradition you can derive equal possibilities from composition in a way. I feel like my generation needed something to grab onto, some sort of structure, and it's the structures of these other disciplines that allow us to do that. We can take and then destroy and be naïve with them and mis-understand them and create absurdities with them, which is why sometimes when seen from the traditional disciplines, we might be seen as unprofessional. This is not theatre, this is not dance, this is not music, because it is coming from somewhere else. It's still firmly rooted in some kind of script.

MEROMI: I'm very much with you on this idea of the fascina-
tion with the script, and for me sometimes it is very impor-
tant to divide the script and the performance. The script has
all the elements that are really interesting. The script generates
the rehearsal. The script generates this place where we can sit
and read and try out the roles and deal with the questions that
it raises. It's full of potential, and it is economically handed
down through the generations. I come from a generation that
is super embarrassed by performance, theatre, by all of this talk.
It's really, why are they talking so much? And in a way the
script provides a way to bypass it. I prefer that we sit and read
together and work out the thing. It's like a softened version of
the theatre. The world at the moment is so thirsty for places,
for open-ended live encounters, and what better place to do it
than in the territory of the script. There are super smart, amaz-
ing scripts. When I do my things, I take a script that I'm inter-
ested in, but in the end it will just end up being like a silent
film, and you will look at the social dynamic that is happening
there. The last thing that you want to see is a bad rendering of
Brecht by me. That's not what I am good at, or that is not the
point. But we had a really good time thinking about it while
we were working.

I come from being a visual artist, which is this perverse
medium where you make something, you put it in the room,
you leave the room, and then you hope that somebody does
something with it, you don't exactly know what. Part of the fas-
cination with theatre is this live encounter, this exchange which
is very rich and full of potential and dirty and dangerous.

HELGUERA: Theatre for art today has become a ready-made. But also the traditional structures of theatre are very useful to advance certain things that we are talking about in this conversation about contemporary art. I think in theatre things are actually going the opposite way, saying, "Oh, look at Marina Abramović, she's really interesting, and like, wow, should we think about that." The reality is that these conversations are very similar; it's just the places where these things originate are very different. Because if you're in theatre, you have to deal with that tradition in the same way that we have to deal with our own set of problems. It feels like they are very different conversations but, in the end, they are completely mixing. The thing that most artists will ask is, "Do you do theatre or do you do art?" I will tell you, I don't care. I'm exploring something, and it is what it is.

SIMMONS: In December there was Nature Theater of Oklahoma's production of *Romeo and Juliet*, and it's very similar to what we do in the sense that they took first-hand accounts of people saying what they thought *Romeo and Juliet* was. They were engaging the stranger and then they were talking the parts of the stranger and making a new narrative. I feel like we're all in conversation.

MEROMI: It is also a matter of different ignorances. I'm ignorant of the history of theatre so I allow myself to do something that would be terribly uncool if I had gone to theatre school. I allow myself to maybe discover things that you guys will miss, and vice versa. That's a convenient way of thinking about it.

California Conceptualism

A Conversation with William Leavitt

Theatre can provide a framework for visual artists to work freely with both the traditional trappings of fine art and the elements of stage production. As assemblage and installation art developed in the post-war era, theatre offered a ready reference point for the experience of these new three-dimensional structures: the stage set. The stage set is an invitation to narrative action, and it is therefore not surprising that the breakthrough into these new forms of three-dimensional work led some artists to take up theatre, writing texts and performing them in environments that they create. The concept of the stage set also allows the artists to raise questions about the hierarchies of fine art, as art objects are subordinated to a larger physical enclosure and an experience with multiple other aspects, including performance.

Such is the practice of WILLIAM LEAVITT, a Los Angeles artist who came to prominence in association with the rise of conceptual art in Los Angeles in the 1960s and 1970s. Some of his work consists of stand-alone, fixed physical objects. They are composites of building materials, furniture, art, and other home decoration. They often directly and objectively represent the California lifestyle in domestic architecture. Leavitt's dry mimicry prompts contemplation since the objects are disconnected from the rest of the absent house and land, a fragment of a lost civilization put on display for close examination.

Leavitt's work as an artist also extends to full-scale theatrical productions, for which he writes the texts, designs and builds the sets, and directs. Though the dialogue is wacky, he sticks to telling a story of sorts and believes in the use of character in a fairly traditional way. Like his sculptures, his theatre pokes at utopian visions of suburban America in the golden age of the country's supremacy. Although he lives and works in the U.S. capital of media production, his sculpture and theatrical productions are resolutely, perhaps ironically low-tech.

His work has been featured in numerous museum exhibitions, including *Los Angeles 1955-1985: The Birth of an Art Capital*, Centre Pompidou, Paris; *In & Out of Amsterdam: Travels in Conceptual Art, 1960–1976*, the Museum of Modern Art, New York; and *Reconsidering the Object of Art: 1965–1975*, the Museum of Contemporary Art, Los Angeles.

The interview took place in his Los Angeles home in January 2012, as some of Leavitt's work was being shown and one of his plays (The Particles (Of White Naugahyde)) *was produced at The Annex in connection with Pacific Standard Time, a series of exhibitions and performances in and around Los Angeles that were organized by the Getty Research Institute, and dealt with the development of art in that area in the period 1945–1985.*

YOUNG: You have worked in both the visual arts realm and theatre.

LEAVITT: The work that I did in the early 1970s started with stage-like installations and one of them gravitated to the stage.

I think at that time I had an interest in stage sets and how they worked in the space—and it's a kind of primitive theatre. I don't even feel that it was really adding much to the literature or the craft of theatre, but I did start from a set-like place. Once I had written a couple of plays I said, "Well, you know, this is more than just providing words and motions for these sets." I spent a lot of time working on various plays, some of which were produced and some not. I think my identity didn't really accept this theatre side. I mean, I started out as an artist and then I had readings and productions, but I didn't feel like I was really part of theatre.

YOUNG: Your training is as a visual artist.

LEAVITT: Yes, as a visual artist, at Claremont Graduate School and the University of Colorado.

YOUNG: What was it that initially drew you to explore theatre as a medium of thinking about things theatrically?

LEAVITT: I did a large-scale installation called *California Patio.* It wasn't so large. It's basically all walls with a patio door and some plants, but it was a stage set. It had a short text that said what people were doing before dinner. I thought, "Well, okay, let's make it a play." So I wrote a short play called *The Silk,* which was a soap opera. And then I wrote another one, *Spectral Analysis,* which is more, I think, abstract. It has snippets of dialogue against a curtain that had the spectrum on it which relates to the color bars of TV. I think that was working against or for television at that point—the television industry here.

YOUNG: When you started to work in theatre, did you think of it as something that was contrary to the visual arts aesthetic? I ask that in the context of Michael Fried's famous diatribes.

LEAVITT: Oh, yeah, yeah. I said they were compatible. I thought that my drawings were illustrations for stage sets, and I didn't do a lot of paintings at that time. The paintings were props for these plays that might take place.

YOUNG: The theatre and the texts and the performative aspect of it really became central, and the physical objects that you created you considered secondary.

LEAVITT: I don't know if I thought of it as secondary, but I must have. I thought they would be work for a purpose, that an illustration is to show something that's going to happen later. I liked that it didn't have to be an artwork by itself, that it could be used to create something else, which is a traditional use of drawing.

YOUNG: Then you started participating in the experimental theatre scene then in Los Angeles.

LEAVITT: LA was a small community at the time in terms of theatre, and I met actors and directors and playwrights. Rob Sullivan—I've known him since the early eighties—and Tony Abatemarco—he's a long-time LA theatre director. He started a theatre club downtown, so I was part of that.

YOUNG: What was that called?

LEAVITT: We just called it The Theatre Club. We did events once a month or twice a month, and people presented work.

YOUNG: And the people presenting work there, were they theatre artists or visual artists?

LEAVITT: Mostly theatre artists, and I was kind of a tag along visual artist who had done theatre. And there is also a fairly good tradition of alternative theatre in LA—the Padua Hills Playwrights group, Murray Mednick and John Steppling. And stylistically, I would imagine, it's probably different from east coast theatre.

YOUNG: How do you think that's true?

LEAVITT: I can't speak from a lot of experience. I have seen some theatre in New York and quite a bit here. I can't really say, but what I've seen in New York is not the same. The Wooster Group is maybe the closest to it but it's a little more media-oriented, I think.

YOUNG: In LA?

LEAVITT: The Wooster Group in using technological devices and so forth. I don't think stylistically that's LA.

YOUNG: So, contrary to expectation, LA being the media center of the world.

LEAVITT: It didn't follow that path.

YOUNG: Just looking at your set for the production last night [*The Particles (Of White Naugahyde)*] at The Annex in LA in

January 2012) and then also the piece that's at Pomona College [*California Patio*, 1972], it seems that they are obviously directly addressing the California lifestyle in the post-war era. What is it that drew you to that subject matter?

LEAVITT: I think I came to California as an outsider, and I looked at it as an odd place. I thought, I want to do something with that. I think it's a kind of fascination with the way everyday things look and how they can affect people—like an attractive home, basic items. It seems like people put a lot of desire into being in them, acquiring them, acquiring this lifestyle. So, I wanted to take a look at it from my sort of distorted perspective.

YOUNG: Did you do that out of an individual impulse or were you also reacting to the social upheaval and criticism of the time? Was it a political aim, or did you have any kind of ideas in mind at the time and looking back at the work than you did then?

LEAVITT: I don't know how political it could be, but I think it's just an examination of what I was interested in.

YOUNG: When you began working on these theatre pieces, did you encounter resistance from people in the visual arts community because you were crossing over into this other medium?

LEAVITT: No. No. I mean, I think it was a very open time in terms of what was accepted. I'm speaking of mid-1970s, 1980s. There was public support for artists to do other things besides painting and drawing, and I think there was also an audience that expected, "Hey, show us something different." It wasn't a

theatre audience, but this audience wanted something new or something they expected to be new. So, I don't think there was any resistance.

YOUNG: The audience that you're talking about, is that a theatre audience or a visual art audience?

LEAVITT: I think it would be the visual art community. My community was more artistic even though I realize I do have a lot of connections in the theatre community. I think in the late 1980s it was more difficult to do theatre in the art context.

YOUNG: You mean when the art market boomed?

LEAVITT: Yes, and at that point I think I got closest to working in theatre. I had readings in playhouses in town, and maybe I wasn't in a position to really have productions of my work even though some pieces were produced. I always held back a little bit, and, even though I think the later pieces are more theatre-like than art-like, I didn't push them to performance. Then, when I did get opportunities to do works, say in 1990, I had a proposal from the Santa Monica Museum saying, "Hey, do you want to do a piece?" and they gave me $3,000, and I said, "Yeah, I can do this short play." So, we did that. I redid another play that year. But I didn't try to go into the theatre world and get productions for these pieces. I guess it wasn't what I wanted. My audience was the art world.

YOUNG: I believe that in the piece I saw last night all of the performers involved are trained as professional actors. Has that always been true in your performance work?

LEAVITT: Yes. I did use actors because it was easier for me.

YOUNG: Because very often in the visual art context, even for visual artists who are doing something that's performative or more theatrical, there is an antagonism toward a trained actor or that kind of mindset in the performer. It is regarded as disingenuous or artificial or too theatrical. But that was not the choice that you made.

LEAVITT: No. I wasn't worried about that.

YOUNG: Why not?

LEAVITT: I think I wanted something more of an imitation of theatre than a kind of artistic free-form piece. A lot of my work does deal with artifice, and I knew it wasn't really theatre, but I wanted to kind of approach it in that way. I thought the best way to do that was to use actors who would make it less jarring for the audience, even though the scripts might not be what people expected for theatre. I did the first play at the Barnsdall Park Theatre, *The Silk*, and I hired a friend, Tonda Marton, to direct it. She got actors to do it, and she went to the performance with her father. He said to her after, "Well, that was quite interesting. It was like a series of slides." And I thought, that's pretty good. I'm a visual artist, and at the time slides were the mode of presenting one's work. I didn't consciously try to recreate that effect, but that was something that happened.

YOUNG: That's an interesting phrase, an "imitation of theatre." Plato criticizes theatre for being mimetic and seducing viewers into accepting a false reality, an imitation of an imitation of the

truth. You aggressively pursued that imitation of an imitation as your aesthetic.

LEAVITT: Yes.

YOUNG: When you direct, how do you give the actors instructions? What kind of techniques do you use? Do you encourage them to be artificial? Do you encourage them to be more Method, or do you leave them to their own devices?

LEAVITT: I tend to leave them to their own devices because I think that my capabilities as a director are developing. Let's just put it that way.

YOUNG: In last night's piece, there were two directors involved, you and Rob Sullivan. How does that kind of collaboration work for you?

LEAVITT: I think it works pretty well because he's really there on every part of the play. I'm really also producer and set designer. I have a lot of other things to do, and we kind of work together. I mean, I set tonal things or change it if I feel like it's getting too histrionic. I would say my choice is something flatter. We balance each other out in that way.

YOUNG: What do you mean by flat?

LEAVITT: Well, maybe uninflected? I mean that there's not a lot of punch behind the delivery of the lines. We did *Spectral Analysis* as a play. I did it in 1990. Rob Sullivan was an actor in it and I was the director. It had its own style, and then we did it

again last year at MOCA for the retrospective and Rob was the director. Somebody commented, "Oh, it's so much more actor-y." It's not as flat, you know? But I think it's better. I mean, I'm not trying to make a program for flatness. It's just my natural bent. I want people to be involved, if possible, in the show.

YOUNG: You mean the audience?

LEAVITT: The audience. Yes.

YOUNG: The piece at Pomona College and also the stage set I saw last night have an interesting transparent quality to them in that one can see through and around the set. It's non-representational or non-illusionistic in that way. Is that a conscious choice on your part?

LEAVITT: I like to have the edge, so you can see the edge of the set and then you have to go around it and it looks like an island in the midst of something else rather than something closed off like a television screen.

YOUNG: Last night's looked very much like that island. Can you explain why that's a choice for you?

LEAVITT: Sure. You know, maybe seeing sets here in LA on soundstages or something, early on where you're in this cavernous room with this little clump of flats with furniture and lights. You think, "Wow, that's great."

YOUNG: Did you see television or movie sets because you were working in television or film?

LEAVITT: I didn't work in the industry at that time. Later I did actually do some work with the industry, but at that time I just had friends who had parts in a play or a film, and I would come to the set. So, just a voyeur. I wasn't part of the industry. I was an outside observer.

YOUNG: The *Pacific Standard Time* shows are making an argument about LA art, trying to resurrect it historically or to argue for its importance in the post-war era. Do you feel, as an artist, that you have been neglected in terms of your broader recognition? Both the visual arts world and the theatre world have a very New York-centric orientation.

LEAVITT: No. I don't feel particularly neglected. I think this is a good place. There is opportunity. I mean, it's easy to live here. I spend time on the east coast, and for me that was a choice of whether I wanted to live there.

YOUNG: But for you the art historical question of critical neglect of the LA art scene is an argument that doesn't necessarily need to be made.

LEAVITT: No. I don't think it has to be made because there's already a vital, thriving art scene here. I mean there were a couple of shows in the 1960s, like at the LA County Museum, where there was *Sculpture of the Sixties* and *Art and Technology*, and these were huge, blockbuster shows at the museum, and I think they had a kind of latent effect on the community—"Oh, you can make this work, there's a lot of work being done, you can see this work." The shows had some informational quality

that you can't measure. So maybe PST has the same effect. It makes something visible that maybe we assumed, someone like myself just assumed, was already going on.

YOUNG: One of the arguments that PST seems to be making is that LA art was particularly influenced by the industry and intellectual climate of the post-war era, specifically the space and technology and military industries that really drove the economic development of Los Angeles. Was that also true for you?

LEAVITT: I'm not sure. I don't think so. I was much more interested in domestic sociology. Later maybe the noir tradition of LA. Chandler and people like that. It was some kind of influence, yes.

YOUNG: In the play last night, the premise is that these people are living in a prototype or test community to be flown off by NASA to outer space, which seems consistent with the PST argument about production of art through science.

LEAVITT: Perhaps. The play changed from being in Houston. I was at this show that Paul Schimmel curated called *American Narrative/Story Art: 1967–1977*. I did a play there called *Spectral Analysis*, and while I was at the museum hanging out with Paul, he said, "Hey, there's a group from NASA here and they're giving lectures in the auditorium about space colonies. Let's go." So we went to the lecture and after it was over, they said, "Well, are there questions?" and Paul said, "Yeah, how do these people govern themselves in space? When you're up

there, what's the plan?" They had no answer to that, of course. I thought about it, you know? Then they said, "Well, that's a pretty interesting question." A year later I started a play kind of based on that idea, that people would have to deal with themselves in these restricted environments if they wanted to be on board ship or something. I don't think I really exploited that aspect of it at all. Theatrically there would be much more to gain from that if I wanted to go in that direction.

YOUNG: For you it wasn't really a conscious attraction, just an accidental sort of inspiration?

LEAVITT: Yeah, yeah. It was kind of accidental and just kind of an excuse to set this little piece in motion, you know, to get going.

YOUNG: In the visual arts context, there are often suspicions of language and narrative. Do you share any of those sympathies?

LEAVITT: No. Probably not. I mean somebody said, "Well, modern art has ended narrative." I mean that's kind of a commonplace, but then I think that we all have other temperaments than are driven by what modern art says. So my temperament tends towards narratives. I think I followed that.

YOUNG: Another interesting aspect of the play last night was the scene where the neighbor comes in and, at that point, the man working the sound began reading the stage directions and the actor was representing three or four members of the cast. Can you describe that aspect of the play or what your intention is?

LEAVITT: Originally I wrote it for the regular cast, that they would make a costume change and reappear, and we thought, "This is kind of clunky." I mean, you can write things like that, but when it actually gets to producing it, it's sometimes difficult. So then we came up with this idea to have one person play all three characters, and Rob said, "Let's have Neal read the script." So it was a break in terms of style that changed the speed or the focus of the narrative.

YOUNG: The other hostility that I see in the visual arts context and even in a lot of contemporary experimental theatre is a hostility to having characters. How do you feel about that?

LEAVITT: I guess I feel like characters drive the play, so I can't be too hostile. I don't think I would have anything if I felt that way.

The Rebirth of Character

A Conversation with John Jesurun, Joe Scanlan,
Michael Smith, and Elisabeth Subrin

In the so-called "postdramatic" theatre the idea of character has been declared dead, its passing noted along with the dissolution of narrative. The theatre critic Elinor Fuchs pronounced its demise in her collection of essays, *The Death of Character: Reflections on Theater After Modernism.* Heiner Müller had earlier written, "The cancerous path of life in capitalism, as well as the coexistence with it on the common basement planets (it flies to the surface, in the basement death grows), destroys the connection of the actor to private property/his private property: he doesn't play a role any more." Hans-Thies Lehmann, in his widely read *Postdramatic Theatre* concurred. Visual artists, however, have become interested in character as a mutable vessel that can be occupied and reinterpreted to upend the artist-, body-, and identity-centered performance of the 1970s through the 1990s. They are employing character to construct work that critiques the institutions, biases and market forces of the art world and to raise questions about the perception of mediated performance. The deployment of a "fictive self" questions and displaces the widely accepted axioms about the identity of the artist and the work. Even when the fictive selves adopted for telling the story are apparently closely related to the artist and the art world, the construction of a separate character creates a critical distance. The critique is not only of art

112

world institutions and the commodification they support, but also of the nature of character, the reliability of narrative, and the identity of the artist. Character can be used, for example, to explore gender issues in dominant narrative forms.

Although visual artists appropriating theatre are using scripts, they feel considerably freer to enhance dissociation and fragmentation than their counterparts in traditional theatre. Characters do not remain true to themselves, but rather slip and morph in ways designed to draw attention to the concept of character itself, and to the fact that it is perceived seamlessly and uncritically in most contexts. Although the idea of durational performance has been used to some extent in theatre, visual artists have pushed it to the extreme, inventing characters that are performed over decades and in different locations and contexts and media, including large-scale installations, video, and "invisible" theatre, in which the performance may or may not have a spectator even as the performance occurs in the real world in real time. Durational performance allows the character to mutate against a shifting historical and social background. Employing professional actors can also throw a wild card into the performance, as the actors unexpectedly reinterpret the character and even defy the writer/artist by refusing to play the part as directed or recite the lines as written. This would of course be unacceptable in traditional theatre, but the breakdown is something that visual artists have seized upon to create analytically productive work. Visual artists incorporating theatre into their work are often liberated to bend the rules in a way that people working exclusively in theatre do not. Indeed, the willful perversion of traditional dramaturgy is a basic tenet of deploying theatre in the visual arts.

The work of John Jesurun, Joe Scanlan, Michael Smith, and Elisabeth Subrin demonstrates these inventive and subversive uses of character in performance and visual art crossovers.

JOHN JESURUN is a writer/director/media artist based in New York, whose integrated work involving film, set design, text, and architecture, has toured extensively in Europe and the U.S. In 1982 he began his serial play *Chang in a Void Moon* (now in its sixtieth episode) at the Pyramid Club in New York. Since 1984 he has written, directed and designed over thirty pieces. A collection of his plays is titled *Shatterhand Massacree and Other Media Texts*. He has received NEA, Asian Cultural Council, Rockefeller, Guggenheim and Foundation for Contemporary Performance Arts fellowships, and is a MacArthur Fellow.

JOE SCANLAN, a New York–based artist and critic, has over the past decade mounted more than thirty one-person shows in Vienna, Paris, Amsterdam, London, and New York. He has exhibited by way of an alter ego, a character named Donelle Woolford, impersonated by various actors. He has made exhibitions and publications with the Museum Haus Lange, Krefeld; the Van Abbemuseum, Eindhoven; IKON Gallery, Birmingham; and K21, Düsseldorf. His book *Object Lessons*, published by the Kunstmuseum aan Zee, Ostend and Dexter-Sinister, New York, argues that greater democracy in art often leads to the objectification of its participants.

MICHAEL SMITH is a video/performance/installation artist best known for two characters that he portrays (Mike, a naïve adult, and Baby Ikki, an overgrown toddler) to comment on American culture and the art world. Smith has shown his work extensively around the U.S. and Europe at a variety of venues

and has received fellowships from the Guggenheim Foundation, National Endowment for the Arts, New York Foundation for the Arts, Art Matters, and the Louis Comfort Tiffany Foundation. A mid-career retrospective, *Mike's World: Michael Smith & Joshua White (and other collaborators)*, was organized by the Blanton Museum of Art and was also exhibited at the Institute of Contemporary Art in Philadelphia.

ELISABETH SUBRIN's film projects, such as *Sweet Ruin*, *The Fancy*, and *Shulie*, investigate subjectivity, feminism, psychology, and political history. She has exhibited widely in group exhibitions and screenings, including the Whitney Biennial, MoMA PS1's *Greater New York*, the New York Film Festival, the Guggenheim Museum, the Walker Art Center, Harvard Film Archive, the Mattress Factory, VOLTA, Vienna Arts Week, and ICA, Boston. She has been a fellow at the Sundance Institute Screenwriting and Feature Filmmaking Labs, and is Assistant Professor of Film and Media Art at Temple University. She lives in Brooklyn.

The discussion took place on June 2, 2012, at the New Museum in New York.

YOUNG: All of the artists that we have here today refer to theatre or use theatrical practices. Although they present divergent kinds of work in extremely varied venues, there are common themes in the way that they refer to theatre.

The concept of character is important in distinguishing the kind of art performance that is influenced by theatre. It draws

directly upon a dramaturgical concept that has been around for 2,500 years.

The "fictive self" removes the artwork from the identity, body, and biography of the artist. This is a unifying feature among all the artists on the panel today.

Let's start with Michael Smith. He has acknowledged explicitly the influence of theatre, in particular, Beckett, Ionesco, and Richard Foreman. Smith is an artist who performs, acts, draws, and makes installations and video. He has inhabited his two principal characters, Mike Smith and Baby Ikki, for close to forty years now, in both video and live performance, often in large-scale installations. Would you like to talk about the idea of character and how we can see that in your work?

SMITH: Most of my work comes out of a reaction to something. The Mike character appeared in a piece from 1978, *A Night with Mike*. I guess it was in response to much of the work that I was seeing at the time. I had a show coming up at The Kitchen, and I realized I was spending more time at my refrigerator than I was at my desk. I had a deadline so I brought my refrigerator to The Kitchen. Later, I brought Le Car, Mike's car, to the Performing Garage. Another piece was a eulogy for Willy Loman. I started out trying to get the rights to *Death of a Salesman*. I had an idea to call it *Death of a Salesman 2*, a follow-up, but they were not interested, I think because Dustin Hoffman was to do the play on Broadway shortly after. My piece was called *Bill Loman: Master Salesman*, where Mike, this kind of hapless, not really forward-thinking guy gives a eulogy to Bill Loman. It was mourning the entry into the eighties. In the

bookend piece, the end of Reaganomics in 1987, post-crash, where Mike, always a little bit late, is learning from young yuppies about computers. It was a one-act musical. As Paul said, I've worked in various contexts. I did a nightclub variety show for a few years. That was *Mike's Big T.V Show*, a combination of performers, comics and television with music and its own theme song.

I come to theatre mostly via television, so it's sort of variety arts. I have Mike and Baby Ikki. Mike talks, but the baby doesn't talk. And actually, the baby is closest to me, unfortunately.

YOUNG: Let's segue to Joe Scanlan, an artist, teacher, and critic. He has engaged for a number of years in a form of durational performance in different kinds of locations but with a recurring character he invented, Donelle Woolford, a fictional artist persona that is portrayed by different actors over time.

SCANLAN: Most of my work has been object-based, and I would even say that I spent most of my career making props—sculptures that have a kind of indeterminate and varied life. So maybe it was inevitable that I would eventually make a person who would be in relation to those props. That character is a young, emerging, ambitious artist named Donelle Woolford. She started as a name really. I did not set out to have a theatrical project. Like Frankenstein's monster, it got a little out of hand. I mostly have been trying to keep up with this thing that has been created and respond to it since it started about five years ago. I first chose the name, and the first image of the artist that materialized was a picture that I found on a stock photo website that I took because it looked like who I was thinking of.

Donelle does not exist on any time-based media yet. We like the idea that there is a kind of piecing together of who she is that happens only from her work and from still images and then from whatever language, interviews she might publish. So there is a hole in the middle of her existence that we are still thinking about which would be some kind of film or time-based media.

She is largely an object-maker and performance artist. She originally made individual paintings and then started to think of her work as scenes. She made a show called *Studio Scene*: fifteen or sixteen paintings, but they were arranged in three different scenes that performances then happened in, very much indebted to William Leavitt in that sense. She participated in the Sharjah Biennial. She set up a kind of studio as stage set in the museum at Sharjah and met the sheikh of Sharjah and his son and entourage. A show in London about four years ago called *Double Agent*, organized by Claire Bishop, focused on the idea of delegated performance that Paul mentioned in the beginning. The museum commissioned Donelle to make publicity photos when the show traveled to Newcastle. At the beginning of that tour, at the ICA in London, she also set up a working studio in the museum that she inhabited as a performance space and stage. Because she does not make any work, the best that we can do is to show her how to act like she is making work and then she performs that to the best of her ability. I have never really thought of Donelle as a self or as a singular thing. I have always thought of her as a mutable character.

In art there is always the thread of the individual that runs through the work, but in theatre the thread is the character. If

there is a long-running show in a theatre, the person playing the lead comes and goes and they even put out publicity saying "Now playing Willy Loman is so and so." We understand that the character is a vessel that each person steps into. That is something I like as an art idea.

YOUNG: Next let me introduce Elisabeth Subrin. I have wrangled her into this panel under slightly false pretenses. She does not explicitly refer to theatre but I believe that her practices, as she and I have discussed, do incorporate something that is inherently theatrical: the idea of repetition. Repetition is key to her practice in that her films are very often a re-enactment of a previous event, such as a film or photograph. Through this process, she develops characters, which are personified by professional actors in film and video. A good example is *The Fancy*, her film about the photographer Francesca Woodman. Elisabeth fashioned a biography of that artist without, in fact, showing any of Woodman's photographs. Rather, the film is a re-enactment of Woodman's photographs. Another good example is her film *Shulie* which remakes a short film biography of a particular feminist artist and author from the 1960s, not only recreating what we see in the film but also retracing the steps of the camera person, a dual re-enactment of this scenario, of this life, of this character, if you will.

SUBRIN: I'm laughing because I'm sitting in acting classes this summer. I cannot believe I gave you a hard time, because I so deal with the theatrical. The paradigm of identity politics-inspired, essentialist self-performances versus the theatrical, is significant in terms of my work. I feel like I was educated

at almost the height or most aggressive moment in identity politics, in the early 1990s, and so, as a student, it was almost impossible to not think of myself in the work. My early work definitely embodied fictional characters that were so thinly veiled as to be transparent. I had to keep inventing more and more intense devices to get away from myself but still deal with whatever was preoccupying me. I exploited a lot of biographical subjects to do that and that led me to learning about character and character development in different ways.

For example, I was commissioned to take on a script, *Technically Sweet*, by Michelangelo Antonioni, which he never realized. He was not able to get the funding to make it. It was supposed to star Jack Nicholson and Maria Schneider. I and several artists were commissioned to make interpretations of the script. I cast the young actress Gaby Hoffman in dual roles, playing both Maria Schneider's role and Jack Nicholson's role. Jack Nicholson was supposed to play a disillusioned journalist, who moved to Sardinia and was obsessed with riflery, which becomes Antonioni's big metaphor in the whole film. He meets a woman who is only called "the girl." They have a devastating, tormented love affair. The film intercuts that scenario with six months later: he's in the Amazon and is about to die. A plane crash left him there.

Ultimately you realize, although critics who wrote about the script never seem to pick this up, that both parts are really the same story. It's about the terror of love and the terror of the female body. I tore the script apart, found the parts that served my own preoccupations, and then, in a pretty organic way, put these together in two channels. I realized that I had

created a psychodrama between one subject and herself. I am
dealing with the work of a great modernist film director, using
it, recreating it, but manipulating it, so it deals with all my pre-
occupations. The premise of my piece was: what if Antonioni's
film was shot but only little shards of it were left? Tradition-
ally, if you shoot a scene, you'll shoot from one angle and have
all those performances and takes of that character, and then
you'll move to the other side of the room and have the reac-
tion from the other side. What I did was make it seem as if
only one side of the unedited footage exists, almost extracting
the male protagonist from the film. I did play with all sorts of
tropes of Antonioni cinema, trying to recreate, impossibly, his
cinematography. I used out-of-date, damaged film stock. I tore
everything apart so that I could deal with the particular parts
of his script that I cared about but extracted from the whole
script. He is just serving my own ideas. I am imposing myself
on his theatre.

YOUNG: Our next panelist is John Jesurun. You may know John
as a creator of theatre, but he was trained in sculpture at Yale.
After that he worked in television for quite some time before
developing his signature techniques in live performance and
creating theatre. His work often derives or refers to his tele-
vision background and the way that television functions as a
mode of perception. John deals very explicitly with the idea
of character in an apparently traditional theatrical way. Actors
portray individual, named characters. But there is a very sig-
nificant difference in that the entire text and also the concept of
character become very slippery. He appears to be working in a

traditional theatrical medium, but, because of the way the text is constructed, identity and narrative become elusive modalities. It's very hard to figure out exactly where you are. The characters are often very unsure about who they are and what they are doing in this place. There is a fascinating open-endedness to the narrative.

JESURUN: I came out of a visual art background, so I maybe had a healthy disrespect for character and what I thought was the theatrical. What I usually do is design the set and the video and then direct it and also write it. A lot of times I don't use the proscenium. The spectator is sitting inside of what appears to be some kind of an installation with the actors and apparent actors. A lot of my work also connects to architecture and use of space. I am also very concerned with where the actor is and where actors are not, where the voices might come from, which, generally then, tends to screw up anything that will get too theatrical. Sometimes there are videos playing and no live actors. A lot of times there is a combination of live actors and prerecorded actors and live actors on video. Now I have done a piece that is completely connected to the Internet, and lately quite a lot of projections.

People appear on the stage who seem to be characters; maybe the character also might be the actor. The way I've written the piece, however, sometimes makes people confused. They do not know if people are just making stuff up on the stage, just performing. There is an obscurity as to where these characters are coming from, which a lot of more traditional theatrical people seem to have problems with. I find that is

more where the root of our own characters come from, this obscure place that slowly seems to become more definite as we go further and further out into the world and present an image of ourselves. The "fictive character" may be fictive or not, but in my pieces some of the characters appear to invent themselves on stage and then contradict that identity and each other.

YOUNG: Bonnie Marranca has commented in a *PAJ* essay on "mediaturgy" that the mediation in your work—the use of the camera and video screens—becomes an additional character.

JESURUN: Yes. Also the screen as a kind of monolithic character in itself. You know, what is this big wall doing there? Or little wall, like a little screen.

YOUNG: Similarly, as with the other panelists, even though you are presenting a character, what we perceive when we look at your work is something beyond this character. We perceive a critique of the construction of the character and mediated representation. Or, in the case of Michael Smith or Joe Scanlan, we perceive a performed character in an institutional or a museum environment, and how that surrounding also informs us. There are questions about how fully realized or believable that character is.

SMITH: "Mike" actually comes out of my community, I think, which I believe was an avant-garde community. Although that word "avant-garde" was kind of up for grabs at the time, mine was supposedly a cutting-edge community. I was always baffled by it because I came from a middle-class background. They

were using the strategies and antics of the avant-garde, very transgressive ways of going against the grain or going against what was out there. I went back to this slow middle-class kind of character. It very much comes from myself, but in an exaggerated way. I distance it more by adding a certain kind of musicality or a rhythm to it. I looked to stand-up to find a structure. Also, not being able to tell a story very well, I always let non-sequiturs come in, so you jump around, pick and choose from various places.

SCANLAN: I became interested in literally not knowing what I was doing so that the character was first formed in the most basic demographic opposite of myself. Not only that I would not know or have any of my own experiences to draw on to form that character, but also that I would have to rely heavily on an actor to help fill the character out. In terms of the institutional setting, what started to happen accidentally was that a split developed between the work as the work and the artist as a work. I saw both of them as commodities of sorts or personae moving at different speeds in relation to each other, and I did not see that as a problem, but rather as a real practical way to deal with all those bad social situations. If the artist is a kind of wind-up toy that is doing that work, and the work is on the wall or wherever it is, it makes things a lot easier. None of it is me. It makes things a lot easier to deal with. There is a kind of liberty in it. I breathe a lot easier at her shows than at my own.

SUBRIN: I am still thinking about what Joe said about this very consistent theatre tradition of different actors embodying a character—how normal that is for, you know, Philip Seymour

Hoffman to play Willy Loman, right? And then somebody else plays it. I see this vision of a character as almost an empty vessel in which different actors infuse themselves. Then, taking that another step, at least in my work, this thing you were saying about a kind of multi-positioning where we are creating a character with empathy that we can identify with, occupying the character, and at the same time critiquing the character. Gaby Hoffman plays Maria Schneider in three ways: playing Maria Schneider, playing Maria Schneider's role in the film, and as Maria Schneider also playing Jack Nicholson's part. I am exploring the whole ideology of the great white European male art film director and using both sides of these characters ultimately to play different parts of one's psyche: all the ways we can both manipulate and critique and use a surrogate as the same as what we call character.

Young: Character is, of course, embedded in a broader dramaturgical structure that involves scripts and narratives. In much of art performance in the second half of the twentieth century, the playscript was suspect because it predetermined what performance would be. The script reinforced the idea of repeatability, which was disdained in the prevailing ideology, which favored the unique, live event involving the body and identity of the artist/performer.

But all of the artists on the panel are writers who create scripts in order to determine, to a large extent, what will happen in the performance. Nonetheless, they create opportunities in the script for other kinds of liveness, slippages in the portrayal of character, and questions about narrative structure.

JESURUN: The idea of writing a script is only one part of the process. I noticed that different choreographers would set a piece on somebody or would have different dancers play a certain part, not a character really—well, we don't know what they are, but a dancer, who actually doesn't speak—but those moves would sometimes be played by somebody else. I noticed that there was a fluidity in this kind of thing. The dancers did not look all the same. They did not seem to move exactly the same. They were doing the same movements, but they were doing them their own way. So for me, the same thing happened with actors. I found I was able to keep the same script, but the actors were so powerful. They could also manipulate the text. I was freed of completely manipulating everybody, which sometimes I like to do and a lot of times I actually don't. That is one further step in pushing it away from yourself, which I find is interesting to do with a performer and your script. They really can reinvent it for you in amazing ways that you cannot anticipate. I think I may know exactly what the script is until I start working with a lot of different performers. Then I realize that they seem to know what it is more than I do. So character, or whatever we want to call it, is actually born out of the connection of the script and this new person who is inhabiting it.

YOUNG: In your work, one of the themes is that the structure is falling apart. It is out of control. The characters don't know who or where they are. The narrative is disjunctive. But the script and the video projections, to the extent that they are prerecorded, provide certain boundaries for what this play area is going to be and what this liveness is.

JESURUN: Yes, they do. That is one way of hemming it in a little bit, keeping some kind of apparent control over it.

YOUNG: Joe, the fake improvisation in the script for Donelle's performance at the ICA in London was interesting to me. In part, the scripted dialogue actually talked about the performance being improvised, whereas the stage directions make clear that there was no improvisation. On the other hand, the stage directions in other sections of the script called for real improvisation.

SCANLAN: It was almost as if the thing had happened previously, like a courtroom reenactment, except it hadn't. It was canned but new at the same time. For a while as an artist, you can show work and be in group shows and be around, but sooner or later somebody wants to do a studio visit and if you want to continue the performance you need a person. When I first started auditioning, the most important thing was that the actors needed to be able to improvise and be very quick so they could be given just a sentence or a word of instruction to go on for half an hour or an entire opening. The actors that I work with are tremendous that way, even to the point where they can say completely ridiculous things and just roll with it.

We laugh a lot, especially in that lecture where Donelle is trying to be art historical and referential and she says that she is very interested in "Robert" Prince's work, which I thought was fantastic. It was a great slip that was even better than if she had said "Richard," and she knew it but she just kept going. Most of the actors I have worked with have that temperament, which is essential. We artists are all quite attuned to how to behave

in those art settings, and these actors are not. Seeing them be such sore thumbs sometimes and them having to deal with that reveals things to me and puts them in a position of having to decide, "Do I follow the rules that are clearly set in this situation or do I not?" It is up to them. It has really boiled down to two actors primarily now. They have a very nice dichotomy. One of them tends to be very agreeable and conformist and sunny and the other one is quite cranky and skeptical and misanthropic. They are almost like the last two cards in my bridge hand. We can play them for one event or another event that Donelle is going to, depending on whether the three of us want to have the experience be against type or with type. Like what John was saying. I like the idea of playing to people's strengths, but it is also interesting not to. Merce Cunningham really liked to give dancers tasks that they were not good at because he liked how it looked on the stage. That is something that interests me as well.

YOUNG: In connection with the ICA appearance, you sent Donelle out to art parties and openings that were taking place simultaneously in London. She went to a dinner for a White Cube opening and an opening at the Serpentine Gallery, which were, I presume, not scripted events, but part of carrying forward the character you had created in collaboration with the actors.

SCANLAN: Yes. One of the best parts for me is to have our entire trust in the world undermined a little bit. To not know at any moment if whom you are talking to is who they say they are or are they pretending to be someone else. There is a piece by

Jiří Kovanda that I only learned about several years ago but that I think is tremendous. He is a Czech performance and conceptual artist. He was really active in the 1970s. He is also in his seventies and is just now being recognized. He made a piece called *Divadlo* which is Czech for "theatre," where he, for weeks, wrote and rehearsed a twenty-minute scene that he then took out on the street and performed, but told no one that it was happening. There is just one snapshot of it. I like thinking of all the people that walked by him that day, and only he knew that it was theatre. There is something wonderfully annihilating about it that I cannot stop thinking about. There are days when Donelle Wolford goes out to galleries and walks around Chelsea or the Lower East Side and sees shows and informs herself on what is going on but is also acting, and maybe someone turns their head and goes, "Hey, wasn't that…?" Or maybe not, and that's fine with all three of us. We like thinking of that as a theatre with barely known parameters.

SUBRIN: You are doing the same thing, presuming that you are fabricating the work rather than somebody else. You have not hired somebody other than yourself to make the actual work that is in her shows. It is work that you have made technically, but it is not your work anymore. You are producing things that are your work but that are not your work.

SCANLAN: Yes.

JESURUN: Does Donelle or whoever is playing her, does she ever continue—I don't know what we would want to call it—the act with you? When she is again in your presence, do you

ever feel like she is inventing a character, concealing herself, or showing you a fictive self of her own invention to you?

SCANLAN: Yes, the one thing that I was not very good at in the beginning was being at her openings. She would be acting. I would have to act to acknowledge her performance, and I was terrible at it. So it ended up that I just would not talk to her for the entire opening. I mean, all of the actors are quite sensitive to this power dynamic that we're in. That is perfectly normal in film and theatre, much more touchy in art, and the actors have their limits of cooperation for their own reasons that we can still argue about. There are things they will not do or say. They will not mouthpiece something at a certain point.

SUBRIN: That is amazing. So you're hiring actors who refuse to read your lines sometimes.

SCANLAN: Even if I have lines, it really goes out of my hands quite quickly.

SMITH: I found myself in that situation myself, forgetting things completely, just being caught short up there.

YOUNG: In your work, there is a lot of spontaneity in the acting, but the dialogue for both the live appearances and the video is scripted, isn't it?

SMITH: The idea of improvisation sort of panics me. The long pauses help. Because of this hapless character, the audience actually thinks something is going on, when there is not anything going on. The most important thing about improvisation

is always saying "yes" to things, and my basic premise is to say "no" to everything. It creates a repression that instills something in the character, a "blockedness" or something that is unfortunately a little close to myself. It creates a certain dynamic, something that people can project onto and figure out.

YOUNG: Another characteristic that I think unifies the panelists is that your narrative structure is very open-ended, though of course in different ways. For Michael and Joe, the character is portrayed over a really long period of time that extends beyond the performance. Elisabeth, you play with time in such a way that we are neither transported to some historical moment in the past nor exactly to the present. We are bleeding out into some other time-space that is not readily recognizable. And similarly, I think for you, John, the way your texts are constructed, we are never quite sure where we are in the narrative—especially in the most recent work you have created, which has the interaction with the Internet and all these other elements that expand the time, space, and intellectual content of the work.

SCANLAN: I went back and read the famous Michael Fried essay "Art and Objecthood," which is the ground zero for the idea of theatricality, at least in the visual arts, in the gallery setting, and was thinking about how much his definition holds true. What would another definition be? I started to think that theatre now in art means anything that is premeditated as an experience. I have not seen any of John's plays, but what I was able to gather about them from the reviews and the clips that I have seen is that premeditation would become a comfort because, however

much slipping or fragmentation is going on, the structure still tells me that this piece has been worked on. What is happening is not an open and infinitely expanding or endless thing. There are limits, and then I can just sit back and trust the limits even if I am confused or agitated or overwhelmed. Maybe it is a different thing for you, Mike. I would be interested to hear you talk about familiarity because, as soon as I see a picture of that character, I get a smile on my face. I feel like I know Mike the character.

I guess I am asking for advice. So, you invented a character and she developed and everyone got to know the character. Then what?

SMITH: The background changes. The character stays the same, the background changes. That is what I find interesting about the character. He does not change. He gets older, I get older. My concerns change and that becomes part of the background. These are very miniscule changes, but I deal with the everyday so I can keep it moving in the background. If I take Baby Ikki to a place like Burning Man, there is a lot going on in the background. There is a lot to see. But that also means that I have to look outside of myself to make it more compelling for the background.

SUBRIN: As someone who was trained in the avant-garde, it was my job to disrupt expectations, whether I do disrupt them or not. No matter if I am dealing with character, I am always responding to dominant narrative forms. There is absolutely no way to get away from that. Whether I am scratching on film and painting over a character, or creating gargantuan

conceptual conceits, there is still an expectation of narrative with a beginning, middle and end, and that the character will change. Whether it is an indie film or Antonioni or Spielberg, there is the idea of redemption. There are certain narrative expectations to the character which I think are very specific to a moving image practice or a recorded practice. You cannot get away from expectations of character in those contexts, which is both a limitation and I think something which also has informed my work. I've been drawn to it because it was a way to deal with the dominant way we are exposed to identity in the culture.

YOUNG: You just referred to the dominant narrative. Isn't your whole point to raise a critique of that?

SUBRIN: For me there are always multiple things going on. In terms of the idea of recreating pre-existing narratives, there is the psychoanalytic interpretation of the compulsion to repeat. To recreate something is trying to get back to a place, a place you have been and want to return to, or even a place you have never been but you would like to be in. When I am recreating something that I have not even experienced, it is still like trying to go back to another world and insert myself in that space. And then there is this criticality of wanting to revisit a place and master it in a way or change the terms of that space. It is always simultaneously personal, emotional and self-centered. And then there develops a more critical position in wanting to respond to the dominant stories that I have absorbed for my whole life.

YOUNG: Would it be correct to say that you have a political agenda behind this strategy?

SUBRIN: When I came up through identity politics, everything was claimed as political to be legitimate. More recently, I have tried to narrow the idea of politics to make a distinction between electoral politics and a dissident position. There has definitely been a feminist agenda and a critique of what I see as gender issues within narrative forms, but I would say that is just one part of it.

YOUNG: Michael and Joe, I believe it would be true to characterize your engagement with these theatrical practices as a form of institutional critique. Michael, that is how you started doing performance. You were reacting against the performance aesthetic that you saw in the 1960s and 1970s. You were trying to create a different kind of performance to talk about the art world and about performance practices.

SMITH: I actually do not like art about art, but I continue to make it. You want to become part of this club. So if you are not always part of the club you have to criticize it or something. Like I said, I am reactive, and this is some sort of megalithic or larger thing outside of my control. You tend to see hypocrisy and you become part of the hypocrisy and it becomes material to respond to. Institutional critique, that is a little highfalutin' for me. You know, there are comments, commentary.

YOUNG: Fair enough. Joe, you have talked about the art world clinging to the idea of the artist biography. Your creation of the character Donelle is intended to raise questions about that.

SCANLAN: Yes, I do not think necessarily that who we are, or what four or five demographic points says about us, tells us anything about the work. "Oooh, you were born in Ohio. I see. That's why your work is this way or that way." I was thinking on the train down today that if Jeff Eugenides can write a book about a hermaphrodite—and I haven't seen him in the locker room but I don't think he's a hermaphrodite—why can't we have that kind of liberty in the visual arts? That you can have the imagination and the hubris, through research or however, to produce things and people you have no knowledge of. Why not? Maybe we can call it institutional critique. But for me it is about an escape from the boredom that comes with being an artist for a while, and the moment that we are in. The tendency seems to be to figure out what the thing is you are going to do and do it and become a brand, something that is identifiable and consistent. I am not really interested in that. I want to see if it can be stretched or flipped over.

SMITH: I take great comfort knowing you are from Ohio.

SCANLAN: Oh, thanks, Mike.

JESURUN: I couldn't tell.

YOUNG: John, in terms of the substance of your work there are always nefarious background figures in your plays, like Chang in *Chang in a Void Moon*, and the idea about forces that are beyond our control. Your work consistently addresses media and how they intervene in our lives. Is that fair?

JESURUN: I think that is all true. Also what Joe was saying is partially true about the structure in my work, and this connects to writing these apparent characters and also to the use of media. The structure is so, let's say, tightly wound up, and is also wired for possible gaps in things and slippages in open areas where ideas can pop through. It is like being on a tightrope. It is the thrill of slipping and almost falling off, and that to me is a creative thrill, pushing the envelope so much in your own creation that you want to see if it is going to fly again that night. That is partially set into the way I work because it is those gaps that are to me so exciting. When it happens between a number of people, let's say, on a stage, that is kind of an experience that I haven't actually created. I have induced it, but maybe the actors have created it. It messes around with reality in a way or the reality that you think you have created, and you realize that actually it is subject to, yes, forces beyond your control, which is a creative impulse for me—to search for this force beyond our control somehow.

YOUNG: I also see in your work and the work of the other panelists something that Hans-Thies Lehmann referred to in his book *Postdramatic Theatre*. He describes the essence of your theatre as enabling the spectator to observe himself observing the action. I think that is where you're all going. You're presenting something in a performative way, but you also try to create some distance between the performance that we are watching and our perceptual abilities.

SCANLAN: I think that is maybe a better way of saying what I was thinking about with Mike. Once I became familiar with the character, the next time I see the character I am aware of my own pleasure and familiarity with the character as much as I am with the next iteration of his story. I would say that, yes, I would strive for the same. The real challenge that is presenting itself to Donelle Wolford at the moment is that the word is out. There aren't many more people who don't know what's up, but does that mean it's over, or is that just the beginning of having another aspect of the performance move front and center? Okay, it's not just a hoax. "Haha, fooled you." It is a performance. But we are right on the cusp of developing what that means.

About the Author

PHOTO: WEB BEGOLE

PAUL DAVID YOUNG, a Contributing Editor to *PAJ: A Journal of Performance and Art,* also writes on performance for *Art in America.* His work has been produced at MoMA PS1, Marlborough Gallery, the Living Theatre, Lion Theatre, Kaffileikhusid in Reykjavik, and elsewhere. His play *In the Summer Pavilion,* presented at the New York International Fringe Festival and at 59e59 Theaters, has been made into a feature film. Young is a recipient of the Kennedy Center's Paula Vogel Playwriting Award for his play *No One But You.* He translated (with Carl Weber) *Anatomy Titus Fall of Rome* and *Macbeth,* which appear in *Heiner Müller After Shakespeare.* Young also co-curated *Perverted by Theatre* at apexart in New York.